Collins

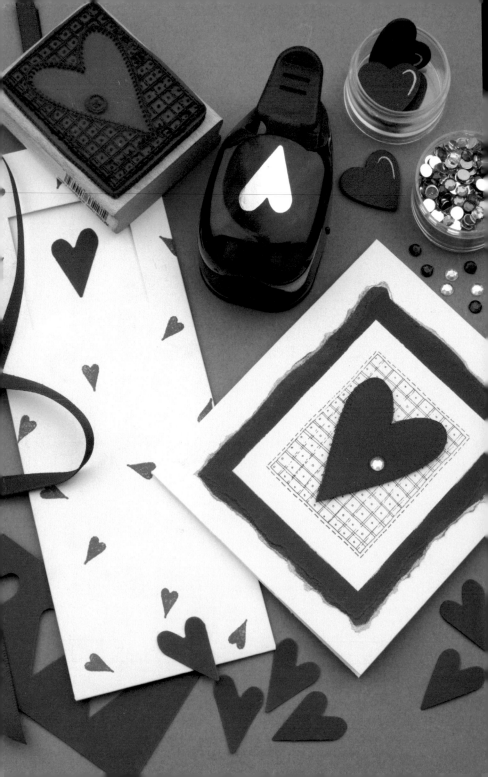

need to know?

Card
Making

Laura Hines

Collins

First published in 2006 by Collins 103788687

an imprint of

HarperCollins Publishers

77–85 Fulham Palace Road

London W6 8JB

www.collins.co.uk

Collins is a registered trademark of HarperCollins
Publishers Ltd

09 08 07 06

4 3 2 1

A catalogue record for this book is available from
the British Library

Produced by Lyra Publications
Managing editor: Emma Callery
Designer: Bob Vickers
Photographer: Nikki English
Illustrations: Anthony Duke

For Collins
Series design: Mark Thomson

ISBN-13 978-0-00-723287-1
ISBN-10 0-00-723287-x

Printed and bound by Printing Express, Hong Kong

Contents

Introduction

Card making has become enormously popular over the past few years. It is a hobby you can do in your own home and in your own time. Your cards can be as easy or as intricate to make as you like and it is an incredibly rewarding pastime. To make that special card for someone can give you as much pleasure as they will get on receiving it.

Experiment and have fun

As card making has become more popular, so the range of tools and materials available, such as embellishments, specialised pens and beautiful background papers, has grown too. There are also several magazines available that are very useful for getting ideas for your cards.

This book looks first at the basic tools and materials that you need for card making. They are not all essential items and can be added to your craft collection over time. For example, a good pair of scissors can be used until you buy a paper trimmer.

The book then moves on to the basic techniques used in card making, starting with making your own card blanks and envelopes. Although there are many different card blanks available to buy, it is very easy and less expensive to make your own. Also, if you want a particular non-standard shape or colour card blank it is useful to be able to make it yourself. The different techniques that are described include such skills as heat embossing, dry embossing, stencilling, iris folding and quilling. The ever popular decorative techniques of rubber stamping and paper punching are also included. There is a huge variety of both these items available and

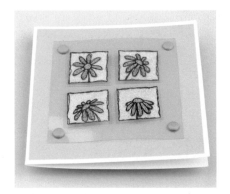

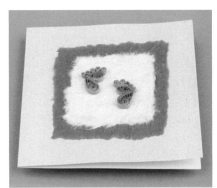

they can be expensive. If you join a local craft group or start your own with a group of friends interested in card making, this can lessen the cost considerably.

Each of the techniques explained in the second chapter of *Card Making* is used in the card designs. With such a wide variety of techniques to inspire you, the designs can be used either exactly as laid out here or as a basis from which you can develop your own ideas.

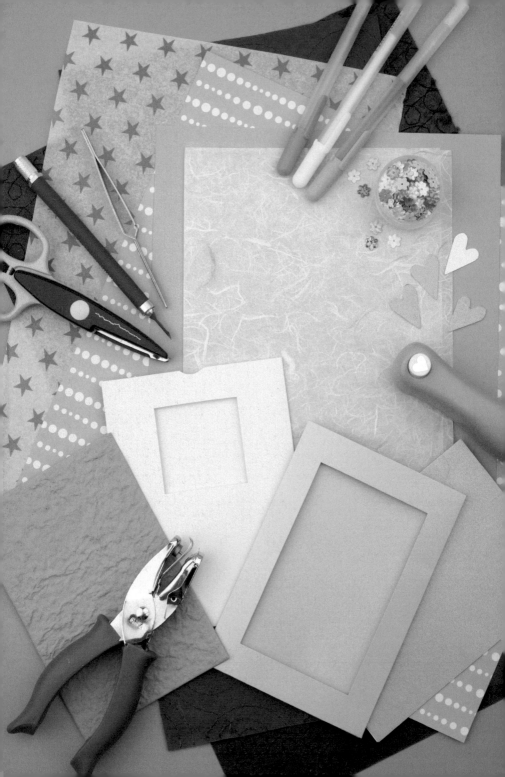

1 Tools and materials

There is a huge selection of tools and materials available from stationers and specialised craft shops. However, when starting out, all that you need are the basic items, such as card, pens, ruler, scissors and a few embellishments. Add to your collection as your hobby continues. This chapter outlines the tools and materials that you are most likely to want to use.

Tools and materials

Divided into different types of materials, the following pages look at paper and card choices, card blanks, pens and pencils, paints and brushes, adhesives, stamping and embossing tools, stencils, eyelets and brads and, finally, all those lovely embellishments.

Tools to cut, measure and fold with

It is more than likely that you will have a few of these objects already, but if not, take a trip to a craft store.

Bone folder This is a small tool (see top left of the photograph opposite) that can be used to crease, score and smooth down folds in paper and card. The pointed end is used to score folds and the rounded end is used to smooth the fold. The folds produced are neat and precise and give your cards a professional-looking finish. Although traditionally made from real bone, they are now made from plastic and Teflon.

Craft knife for detailed cutting. A good, sharp one is essential for cutting neat edges. Take great care when using them as they are extremely sharp.

Cutting mat (self-healing) This is very useful for measuring and cutting card and paper while protecting your table or work surface.

Paper punches These come in a variety of shapes and patterns. There are also many different corner and border punches that can be used to decorate your cards. A single-hole punch is a particularly useful tool to have as it is so versatile.

Paper trimmer A paper trimmer allows you to make quick, clean cuts giving a professional finish.

Plastic ruler Essential for all that measuring.

Scissors It is useful to have a few different sizes of scissors to work with and also some that create a patterned finish:
- Large – for cutting different materials.
- Small – for cutting detail.
- Decorative-edged scissors, such as deckle, wave, scallop and ripple, are available individually or in sets. They range from children's to professional brands.

Steel ruler for cutting and tearing paper and card.

Tweezers Use tweezers for applying stickers, peel-offs and dried flowers to your cards.

Of course it's possible to make cards without a paper trimmer and cutting mat, but if you can afford to buy these items they will make your life a good deal more straightforward.

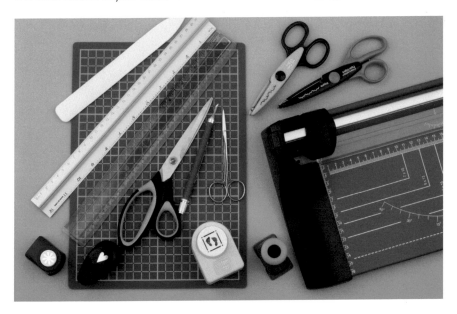

Paper and card

There is a huge selection of hand- and machine-made card and paper from which to choose. It comes in a variety of finishes, such as matt, glossy, pearlised, metallic and corrugated, and also in different sizes. More specialised papers include:

Acetate paper images can be drawn or rubber stamped onto acetate and then coloured in with pens and glitter to give a special effect (for example, see Self-raising flowers on page 83).

Background papers come in all manner of patterns and designs and they can also be used for cutting motifs from.

From left to right, this picture shows the following different finishes of machine-made card: matt, pearlised, metallic, corrugated and textured.

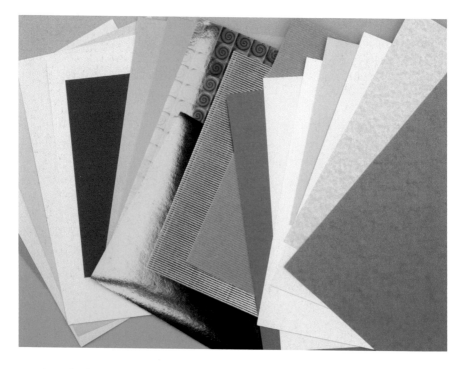

Handmade paper usually has a rough texture and can feature flower petals, leaves, wood and metallic flecks held within the paper. It is more expensive than other types of paper.

Mulberry paper is light, opaque and made from mulberry leaves, and contains strands of silk. It comes in many colours and when torn gives a feathered edge. It is very useful when you are layering paper and card.

Vellum can be plain, coloured or patterned and is semi-opaque. It is lovely to use when creating layered effects and it softens the lines of any patterns on underlying layers.

From left to right, this picture shows the following different finishes of more specialised papers: handmade, mulberry, background and vellum (both plain and patterned).

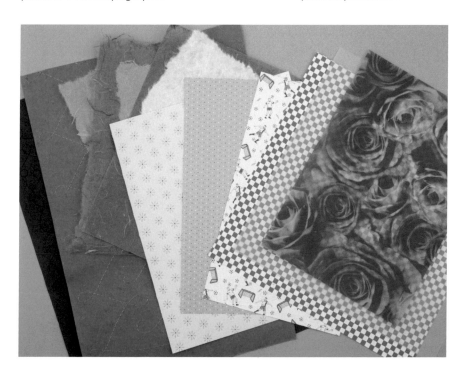

Must know

Make your own
It is always useful to have some ready-made card blanks in your card-making collection, but it is also easy to make your own. See pages 28-9 for instructions on how to do this and if you would like an envelope to match, see pages 30-3.

Card blanks and shapes

There is a huge range of styles and shapes of cards available to buy as card blanks in craft shops and stationers. Many different coloured cards are used for these blanks with matt, pearlised and more textured finishes. There are also more complex shapes available, with and without apertures. The three most commonly available single-creased card shapes are:

- 120 x 120mm
- 105 x 148mm
- 128 x 178mm

For something more complicated, you can buy or make your own double-creased card shapes:

Aperture cards There are card blanks with a wide variety of apertures available. Examples of aperture shapes of varying sizes are ovals, circles, squares, hearts, stars and Christmas trees.

A concertina card can be decorated right across one side, as all three panels will be visible on the finished card.

Gatefold cards open out like a pair of gates and are an ideal shape for invitations.

Three-panel cards are used when the middle panel has an aperture used to display a cross-stitched or embroidered image or a piece of work using iris folding. The side panel on the right can be folded in and stuck down to cover the back of the work. This gives a neat finish to the card.

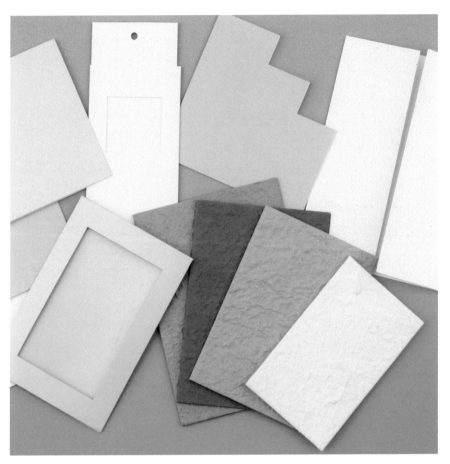

Pens and pencils

There are many different pens available with an assortment of nibs, colours and thicknesses, all producing very different effects. It is useful to have a good range of pens, such as those featured in the photograph overleaf.

Black, fine-tipped pen for writing messages on your cards.

Some examples of ready-made card blanks in a variety of sizes, materials and shapes, both with and without apertures.

Brush nib pens These are similar to a paintbrush and you can vary the thickness of the brush nib, depending on the amount of pressure applied when writing with the pens.

Colouring pens Many come with dual tips – one on each end. Some have nibs of varying sizes, usually fine at one end and medium at the other and others have medium nibs but different shades of a colour at each end. Both types of pen can be used for colouring your cards directly. These pens can also be used to apply colour directly onto a rubber stamp (see page 41).

Crystal lacquer pens are ideal for colouring images with slightly raised edges to prevent smudging. Each colour should be used separately, allowing one colour to dry (15 minutes or so) before the next colour is added to prevent running of colours. The final effect is that of enamel. If bubbles appear when using them, they can be removed by bursting with a needle.

Embossing pens come in a variety of colours, including clear. These can be used instead of ink pads to draw patterns, write messages, colour rubber stamps or colour cards directly and then heat emboss them (see pages 44–5).

Felt-tipped pens for general decorating.

Gel pens come in a variety of colours and finishes, such as metallic glitter and fluorescent.

Silver and gold marker pens are available in

Must know

Storage

With the exception of crystal lacquer pens, all pens should be stored with the lids on and laid horizontally to prevent ink flooding to the tips. Crystal lacquer pens, however, should be stored vertically, point down, and with their lids on to prevent air collecting near the tip. This will prevent bubbles appearing on your cards.

varying nib sizes. These are useful for colouring cards and also for writing messages. Silver and gold marker pens with extra fine and fine nibs are the most useful for message writing.

Soufflé pens also come in a variety of colours and give a lovely, even finish. The ink gives a three-dimensional effect and it starts to flow as soon as the point is pressed onto the surface to be decorated. Soufflé pens are ideal for colouring peel-offs or heat embossed images (see pages 52–3 and 44–5), where there is a ridged area to be filled.

There is a bewildering array of pens and pencils from which to choose. Perhaps start with some felt-tipped pens and gel pens and slowly build up your collection.

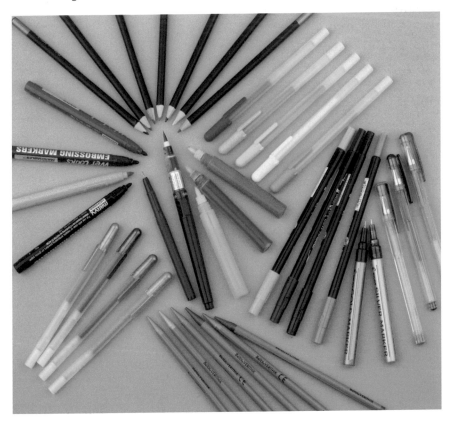

Paints and brushes

It is also important to have a collection of paints – watercolour and acrylic are the most useful.

Include in your card-making collection a selection of different-sized paintbrushes, too. You can buy these individually or in sets of different widths. It is useful to have as wide a range as possible. As soon as you have used a paintbrush it is important to wash it in water (if the paint is water based) or methylated spirit (if the paint is oil based).

Collections of watercolour paints and chalks are readily available in palette form. You can buy acrylic paints in a range of colours – in bottles, as here, or in plastic tubes.

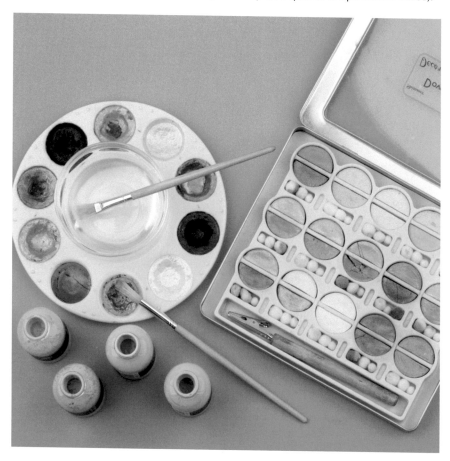

Chalks These can be used to colour your cards and, depending on what you use to apply them, e.g. cotton wool or sponges (see pages 50–1), can give very different effects. They can also be used with stencils.

Adhesives

You will need a range of different glues when card making. Always use solvent-based glues in well-ventilated conditions and store them where children are unable to reach them.

Using adhesives can be very messy and it's important to use the correct glue for whatever you are sticking – you do not want your glue to be visible on your card after it has dried, but equally you do want your glue to work. Specialist glues are available, such as glue pens specifically made for applying metal embellishments or for sticking on vellum.

Adhesive and double-sided tapes Like most tapes, these are available in a selection of widths. Adhesive tape comes in a handy-to-use dispenser. Double-sided tape can be used instead of glue and is quick and easy to use.

Foam pads and three-dimensional tape These are available in different sizes and thicknesses depending on what you are going to use them for. Use foam pads behind a picture or embellishment so that it stands out.

Glitter glue Available in a range of colours – red and blue are readily available in addition to silver and gold – glitter glue gives a decorative glittery finish without the mess of using glue and glitter separately.

Must know
Card designs
If you like the idea of using chalks and think you would like to use some, see the following cards, which feature chalk as an important design element: Hot wheels (page 90), Pink elephant (page 98), Pitter patter (page 116), Cheers! (page 168) and Get well soon (page 174).

Glue dots These are very useful for attaching small items, such as gems, to cards and are available in different sizes and thicknesses, depending on whether a three-dimensional effect is required.

Glue sticks A very popular paper adhesive, these are good for sticking paper to paper, or paper to card, but do not work well on pearlescent or glossy card. Glue sticks are also good for gluing mulberry paper to card as the glue is not visible after it has dried.

Masking tape A most versatile product, masking tape is very useful for keeping anything in place on a temporary basis.

PVA (polyvinyl acetate) adhesive This is white glue that becomes transparent when dry. It is useful for sticking paper to card, or card to card. It can also be used for sticking fabric, ribbon and embellishments, such as beads and sequins onto your cards. It is very versatile and is the glue most frequently used when making cards. It can be squeezed straight from the bottle or transferred to a small tube applicator. If tiny embellishments are being applied, use a cotton bud or cocktail stick. Always put the lid back on straight away to prevent the glue drying and the nozzle blocking. Very fine-bore nozzles are available in plastic or metal and these can be used when doing glitter work (see page 35).

Spray adhesive This glue allows you to glue thin papers such as tissue paper and mulberry paper without them wrinkling or having lumps of adhesive showing on your finished work.

Must know

Gluing techniques
Depending on what you are sticking together, different glues are needed. See pages 34–5 for a crash course in which adhesive to use and when.

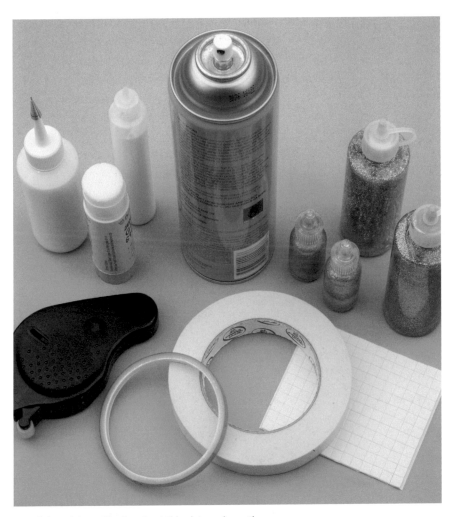

From left to right and back to front this picture shows the following different adhesives: PVA with nozzle, glue stick, PVA in smaller dispenser, spray adhesive, glitter glues, a handy dispenser unit containing adhesive tape, double-sided tape, masking tape and foam pads.

Rubber stamps

These come in a huge variety of styles and designs. They can be used to make your own background paper (and wrapping paper) or be the main feature of your card. Keep the stamps clean with stamp cleaner, alcohol-free wipes or warm soapy water, and store them away from direct sunlight and radiators.

Ink pads Rubber stamps can either be coloured in with pens or used with an ink pad (see pages 40-1). The latter comes in a wide range of colours and there are several types, too. For stamping images and messages, use a quick drying solvent ink pad, but if you are using the stamp for embossing (see opposite and pages 44-5), use a pigment ink pad. This is slow drying and gives time for embossing powder to be applied and heat treatment used.

The essentials for rubber stamping: a variety of stamps (they come in all sizes) and coloured ink pads.

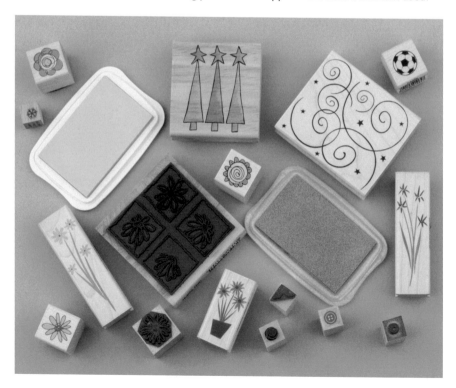

Embossing tools

There are two types of embossing: heat and dry embossing.

For heat embossing, you need a rubber stamp, a pigment ink pad, embossing powder and a heat tool, which is rather like a hairdryer, although you should never use a hairdryer for heat embossing (for a full description of the technique, see page 44).

Dry embossing is done with a stencil, embossing tool and a light box (see pages 46–7). Embossing tools come in various sizes and are usually double-ended. Light boxes can be either fluorescent or have a low-voltage bulb inside. If you do not have a light box, it is possible to use the light from a window or a lamp behind a piece of glass.

Use a special heating tool and embossing powders for heat embossing, and a light box, embossing tool and metal stencils for dry embossing.

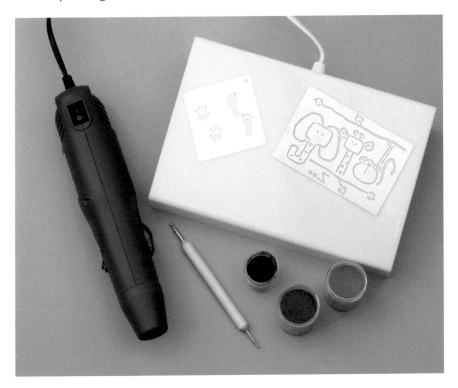

Stencils and templates

Stencils are made from plastic or brass (or coated metal) and are available in a wide range of designs, including numbers and letters of the alphabet. You can also make your own (see pages 48–9). Templates are simpler outlines than stencils and are especially useful for cutting out shaped windows. Templates are also useful for making different shaped cards and envelopes.

Eyelets and brads

Eyelets and brads are decorative metal fasteners designed for paper and fabrics. They are available in many different colours, shapes and sizes. To use eyelets, you will also need an eyelet setter. These can either be used in conjunction with a small hammer – a noisy option – or there are more specialised setters that just require a strong wrist (see pages 56–7).

Eyelets and brads are available as individual designs or in sets of different colours, sizes and shapes.

Other decorative embellishments

The choice of decorative embellishments is myriad. In fact, it's difficult to resist buying more and more of these. Keep an eye out for

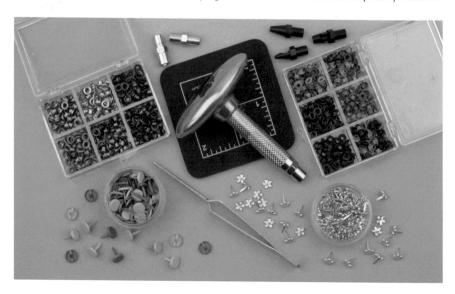

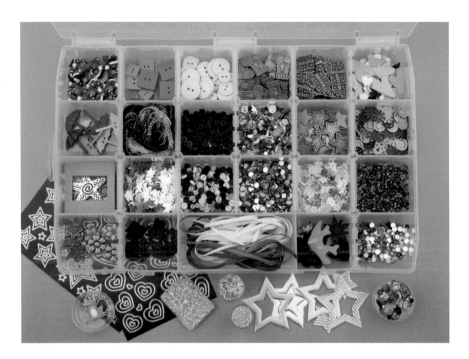

useful storage containers in which to keep them. As well as the main embellishments listed here, there are many other items you can enjoy, including buttons, gems and dried flowers.

Plastic containers with plenty of separate areas are the perfect way to store embellishments, which are often small and fiddly.

Peel-offs and rub-ons There are many, many different types from which to choose. Peel-offs can be used on almost any surface, including acetate and vellum, and decorated with specialised pens, such as soufflé or gel, to create a stained-glass effect. Messages and letters are also available as peel-offs and rub-ons.

Ribbons, thread and yarns These can be stuck directly onto your card as borders or for such design features as a handle for a bag, or tie them around your card to finish it off.

Wire and beads Choose from different colours and thicknesses. Peg boards can be used to shape the wire.

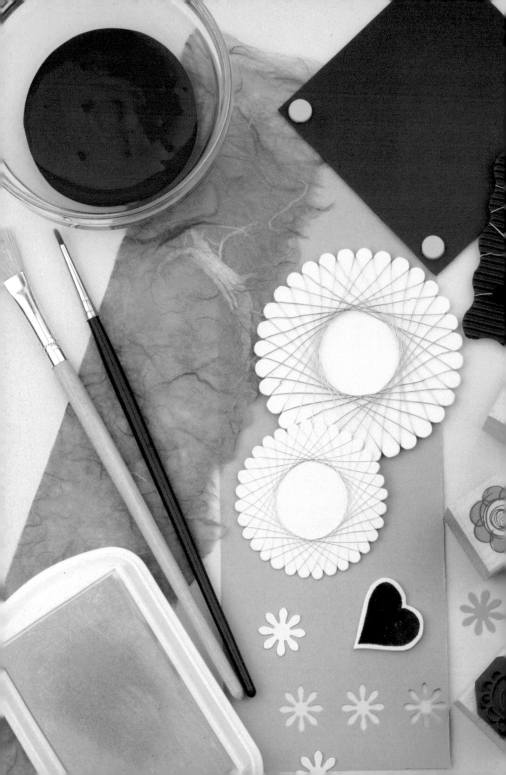

2 Basic techniques

This chapter starts with how to make your own
card blanks and envelopes, and then goes on
to give an outline of different ways to use
adhesives and how to tear paper and decorate
paper edges. Further techniques explained here
range from stamping, embossing, stencilling
and chalking to iris folding, teabag folding,
quilling and spirelli. A wide spectrum indeed.

Making card blanks

Card blanks are readily available in stationers and craft shops. However, they can be made very easily and at considerably less cost. It may be necessary for you to make your own card blank if an irregular shape is required.

You will need

card
paper trimmer or scissors
pencil
metal ruler
bone folder
eraser

Making a blank

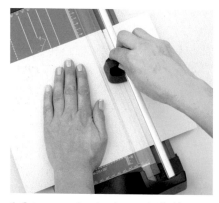

1 Cut your card to the size required with a paper trimmer or scissors.

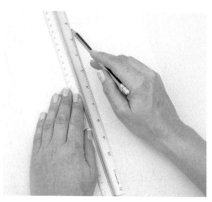

2 Find the middle of the card and using a pencil and ruler draw a faint line down the centre of it.

Useful tips

- Most of the card designs in this book use homemade blanks rather than ready-made ones.
- The dimensions that are given for each card are for when they are folded. When cutting the card, therefore, double the length of the edge that is folded in half.

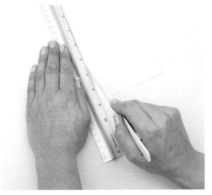

3 Score along the pencil line using a metal ruler and the pointed end of a bone folder.

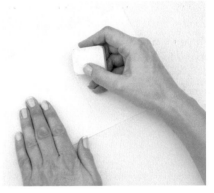

4 Rub out the pencil line with a clean, soft eraser so that no marks remain on the card.

5 Fold the card in half along the scored line and use the rounded end of the bone folder to smooth the fold down.

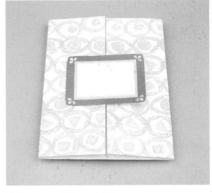

6 For a gatefold card (this one appears on page 144), fold the edges to meet in the middle and smooth firmly with the bone folder.

Making an envelope

Like card blanks these are readily available in stationers and craft shops but they can be made very easily and cheaply. Templates are available in various shapes and sizes.

You will need

sheet of paper
envelope template (see page 32)
pencil
scissors (or cutting mat and craft knife)
metal ruler
bone folder
decorative lining paper (optional)
PVA adhesive

Making an envelope (optional lining)

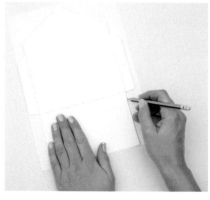

1 On a sheet of paper draw around the template using a sharp pencil.

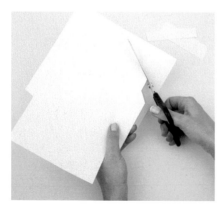

2 Cut out the envelope shape.

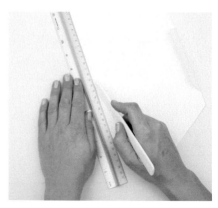

3 Score the side fold lines using a metal ruler and the pointed end of the bone folder.

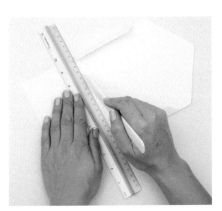

4 Fold the side flaps in towards the centre and then score the bottom edge fold.

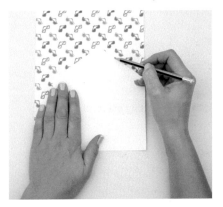

5 If lining the envelope, trace around the template on the decorative paper and cut out. If not lining the envelope, go straight to Step 7.

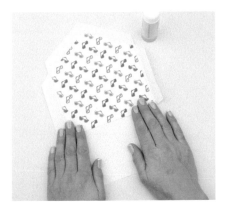

6 Stick the lining on the inside of the envelope, positioning it within the flaps.

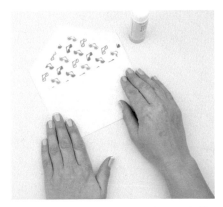

7 Glue the flaps and fold up the bottom half of the envelope to secure.

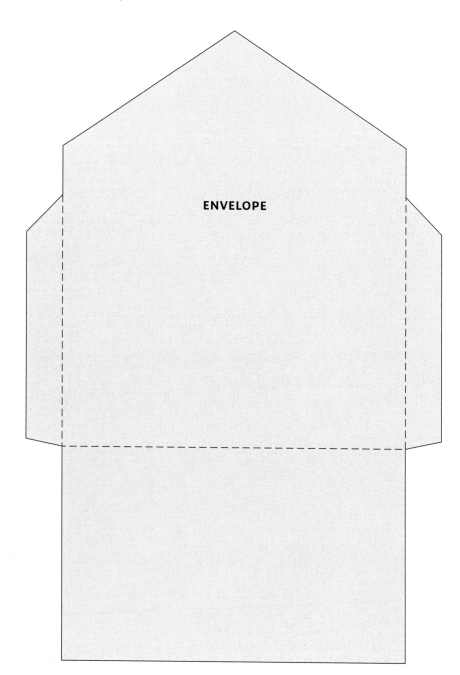

ENVELOPE

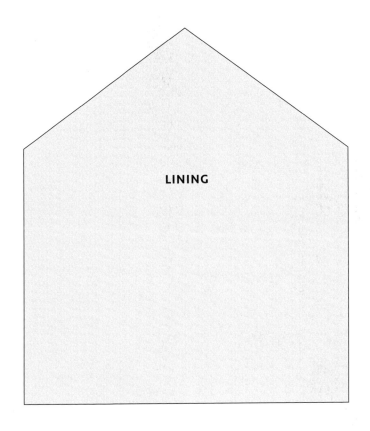

LINING

So that these templates fit well on a piece of card measuring 295 x 210mm, enlarge them on a photocopier by 170 per cent.

Using adhesives

Using adhesives is, of course, extremely straightforward but with the wide choice of glues that are available, there are some useful techniques to be learnt.

must know

Spray adhesive
Spray adhesive should be used with care and preferably inside a cardboard box as the spray can drift. Spray on the adhesive, following the instructions on the can, but it is usually from a distance of 150-200mm. Ensure that you are using the spray adhesive in a well-ventilated room and store out of the reach of children as it is solvent based.

Different adhesives, different methods

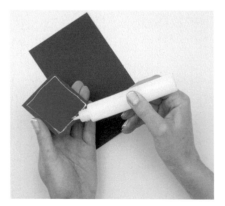

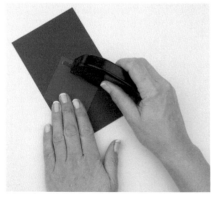

1 When using PVA adhesive, take care not to apply it too thickly and not near the edges as the glue will spread out when the two surfaces are pressed together. It will then seep out and spoil your card.

2 For adhesive tape, trace the dispenser tip around the edges of the item to be stuck, allowing a thin layer of adhesive to be applied.

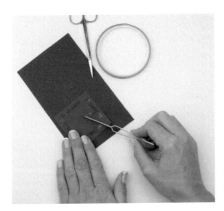

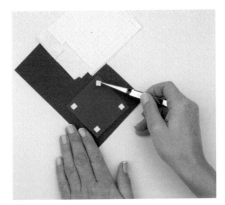

3 If you are using double-sided tape for joining together two pieces of card, cut the tape to the desired length and apply to the back of the piece of card you are working with. Then remove the backing of the tape and stick onto your card, pressing gently.

4 To use foam pads, apply the foam pads to the back of the item to be stuck. Peel off the backing from each pad, which can be fiddly and is sometimes easier to do with tweezers.

5 When using glue dots, apply them straight from the backing onto your piece of card or embellishment.

6 To stick glitter or small beads, use either a specialist glitter glue (a fine metal nozzle is useful for detailed work) or use PVA adhesive. Coat the adhesive with your chosen glitter or tiny glass beads and shake onto spare paper or card to remove the excess.

Decorating edges

One of the simplest ways to add variety to a card is to make decorative edgings either to the main card itself or on as many layers as you choose. For an obvious pattern, use decorative scissors, for something a little more subtle, there are several different paper-tearing techniques.

Using decorative scissors

A variety of different decorative scissors are available, e.g. deckle, wave and scallop. See the pictures below for some of the effects you can create. As you cut along a strip, make sure you align the pattern on the scissors.

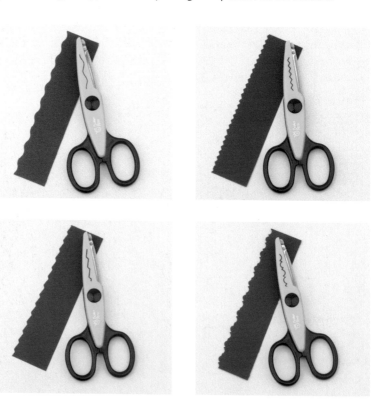

Paper tearing using water

This is ideal for thick card that is difficult to tear or for mulberry paper to get a feathered effect.

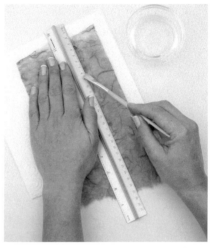

1 Place a metal ruler parallel to the edge of the card or paper.

2 Wet the paper with a paintbrush and allow the paper to absorb the water.

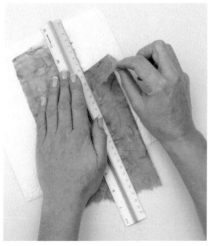

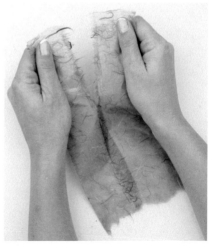

3 Slowly tear the paper …

4 … or pull apart. The tear needn't be in a straight line – you can gently tease the paper to make the tear wavy.

Paper tearing using a ruler

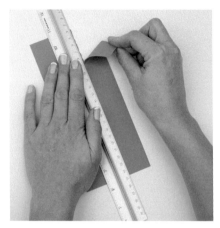

1 Place a steel ruler close to the edge of the card or paper remembering that the finished effect will depend on the grain direction.

2 Pressing down on the ruler with your left hand, hold the paper between your forefinger and thumb and slowly pull it towards you.

Paper tearing by hand

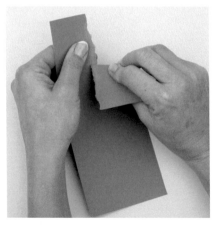

1 This gives a more irregular edge than using a ruler although the grain direction again affects the end result.

2 Tearing on the back or front of the paper also gives you a different finish.

Colouring torn paper edges

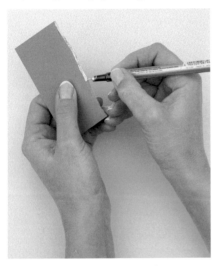

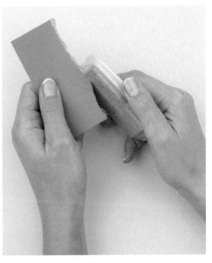

1 This can be done in a variety of ways, depending on the effect required. Colour the torn edge using felt or gel pens or pencils.

2 Brush an ink pad along the torn edge.

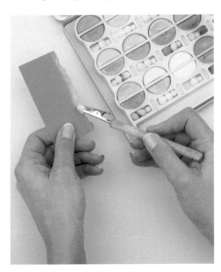

3 Apply chalk using a damp sponge or an applicator that holds small cotton wool balls.

4 Use glitter glue. (If the nozzle should become blocked, use a needle or pin to clear it.)

Stamping

Rubber stamping is a quick way to add a single image to a card or for a repeat pattern. Use ready-made stamps or make your own from potatoes (see over) or sponge. These are best for simple images such as circles, squares and hearts.

You will need

rubber stamp
ink pad or felt-tipped pens

Rubber stamping

For the quickest result, use an ink pad with the stamp. In addition to the water-based and pigment ink pads there are other more specialised pads that you can use. For a very faint image or one that

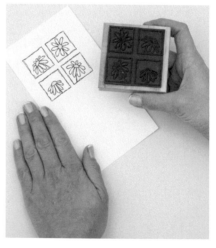

1 Ink up the stamp using an ink pad, ensuring that all the stamp is covered evenly. If the stamp is small, put it on the ink pad. If large, as here, it is easier to bring the pad to the stamp rather than the other way around.

2 Position the rubber stamp onto your chosen paper and press firmly and evenly. Lift up the stamp and leave to dry.

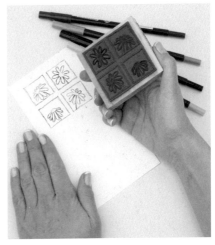

Useful tips

- Remember that an ink pad will dry out very quickly if the lid is kept off it for any length of time.
- For a large stamp, press down with both hands for an even finish. You may even need to stand over it to press down for the best results.

you want to apply chalk to, use a clear watermark pad. For stamping onto surfaces other than card, such as plastic, metal, glass, leather and ceramics, use a solvent ink that is very fast drying.

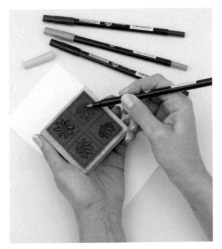

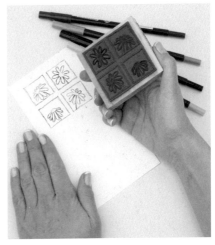

3 Instead of an ink pad, use felt-tipped or gel pens to colour the stamp. If the colours run into each other on the stamp, worry not – the end result can be very effective.

4 If you are worried that the ink has dried before applying the stamp, breathe onto the stamp and then press down on the surface to be decorated.

Potato stamping

This is a very easy and fun technique that children will love to help with. A repeat pattern is produced by cutting a shape into a potato and using it to print your design. The size of potato will depend on the size of image required. The card on page 144 has been made using new potatoes but if the image you want is a large star or circle, you will obviously need a larger potato. You could also use a sponge in exactly the same way, cutting around the image that is drawn onto one side.

Potato stamping can be done using a variety of inks or paints in various ways. For example, apply ink using a rubber ink roller to spread the ink to a thin consistency and then press the potato onto the card several times, or press the potato directly onto an ink pad. When printing an all-over pattern, it will be more visually satisfying if some of the images are incomplete around the edges of the card.

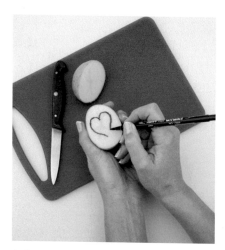

1 Cut your potato in half and draw the shape you require onto the surface.

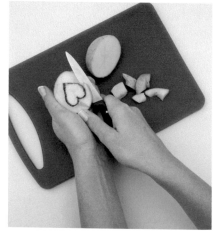

2 Using a sharp knife or craft knife, cut out the shape. Cut around the outline at 90 degrees and then cut around the potato and lift off the excess.

3 Place the cut edge of the potato face down on a sheet of paper towel for 10 minutes to allow it to dry before printing.

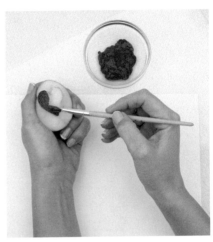

4 Apply paint to the image using a paintbrush as only a thin layer of paint is required. A paintbrush also gives you a more even finish than if you were to dip the potato into the paint. This method also ensures that all the surface is covered with paint.

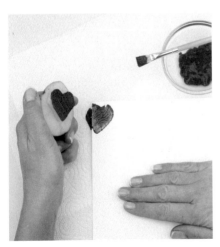

5 Press the stamp firmly onto your card, evenly and using both hands. Lift it up, being careful not to smudge your image.

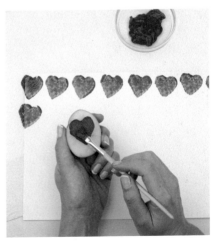

6 Reapply paint and repeat your pattern. If your shape is more abstract, you might choose to turn the stamp slightly each time (see the card on page 144 for a good example of this).

Embossing

There are two kinds of embossing: heat embossing uses powders that change to a wonderful glittery finish as they dry, and stencil embossing (see overleaf), which gives your card an attractive three-dimensional finish.

You will need

rubber stamp
pigment ink pad
embossing powder
paintbrush
heat gun

Heat embossing

This technique involving rubber stamping uses a slow-drying pigment ink pad. This gives time for the embossing powder to be applied and the image to be embossed using a heat gun. To create a raised, shiny image, use a coloured ink pad and clear embossing powder.

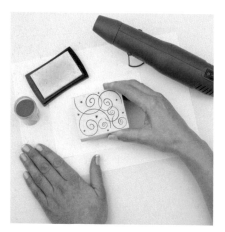

1 Stamp your image using a rubber stamp and a pigment ink pad (see page 40).

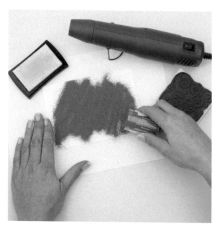

2 Sprinkle the image with embossing powder before the ink dries. Pour the excess powder back into the pot for re-use.

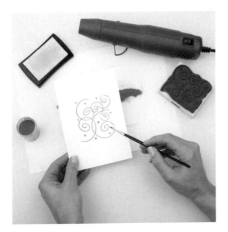

Embossing powders are available in many different colours, including metallic shades, which are very effective and give a lovely finish to your cards. The image to be embossed can be applied freehand using an embossing pen rather than with a rubber stamp and ink pad if you prefer.

Useful tips

- If you do not have a heat gun, do not use a hairdryer. Instead, it's possible to hold the card close to a hot iron until the embossing powder melts. But DO NOT allow them to touch as this will ruin your iron.
- The inkpad doesn't have to be clear as the embossing powder will keep its own colour.
- Embossing powders are much darker and less glittery than their finished colours.

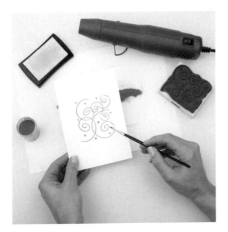

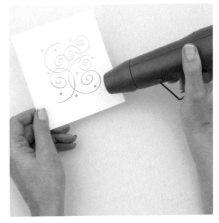

3 Use a small paintbrush to remove any specks of powder that have stuck to the card around the image. This can be minimalised by handling the card/paper as little as possible so that grease from your fingers is not present, or by dusting the card with an anti-static cloth before stamping your image.

4 Use your heat gun to melt the embossing powder. Keep the heat tool in one place, about 10cm (4in) away from the image. When the powder begins to melt it will turn into a brightly embossed surface. Move the heat tool slowly across the image until it has all melted.

You will need

masking tape
stencil
card
light box
embossing tool

Useful tip

If you don't have a light box, use a glass table with a torch shining up through it or tape the stencil to a window.

Dry embossing

Dry embossing is the process of raising a pattern on a piece of paper or card. It is done by tracing over a stencil with an embossing tool. The best stencils to use are brass or coated metal, but plastic stencils are also available. You can also make your own stencil by cutting out your design using a craft knife on a piece of card or acetate paper (see pages 48–9).

Embossing tools come in various sizes and are usually double-ended. When tracing the outline of the pattern, use the bigger end and don't press too hard or the paper or card may tear or crease. If you do not have an embossing tool, you can use the end of an old, empty ballpoint pen.

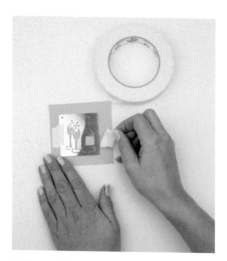

1 Use masking tape to attach the stencil to the piece of card.

2 Place the stencil and card onto the light box with the stencil facing down and tape in place.

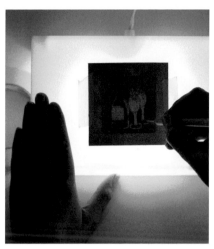

3 Switch on the light box and rub the large end of the embossing tool on your hand to help prevent friction building up. You might need to repeat this as you emboss.

4 Trace around the outline of your design using the large end of your embossing tool, only using the small end for smaller parts of the design, which cannot be outlined using the other end.

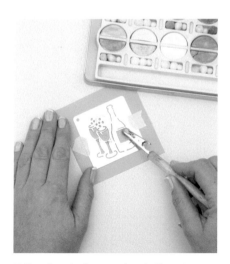

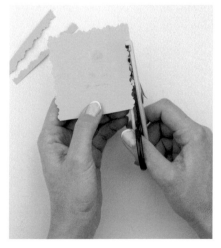

5 To colour the image using chalk, turn over the card and stencil and colour from the front. For fine details that the applicator won't fit through, remove the stencil and lightly chalk.

6 Remove the masking tape and stencil from your card, cut out your design using a paper trimmer or decorative-edged scissors and stick to your card.

Stencilling

In addition to all the many wonderful stencils that you can buy, for simpler outlines it is quite possible to make your own – all you need is a piece of acetate and a pair of small scissors or a craft knife and mat.

You will need

pencil
scrap of paper
piece of acetate
small scissors or craft knife and mat
masking tape
pen or a paint of your choice

Making your own stencil

A stencil is best used for repeating a shape on one card or if you are wanting to make several cards featuring the same design. If you are making your own stencil, make the shape as simple as

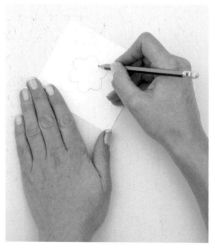

1 Draw your design onto the paper, keeping it as simple as possible.

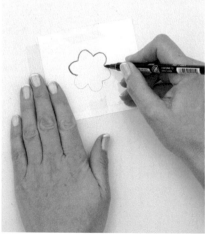

2 Trace through the acetate, but remember that if you are dry embossing with your stencil, the finished design will be reversed.

possible and remember that the area you are cutting out shouldn't be too large as the edge of the acetate can lift up from the surface of the card allowing the pen or paint that you are using to spread under its edge.

Useful tip
If you have a rubber stamp that you like the design of, stamp this onto the acetate and cut it out as described.

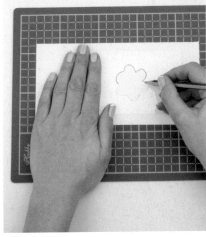

3 Cut out the stencil using scissors or a craft knife and mat.

4 Fix the acetate stencil to the surface to be stencilled with small strips of masking tape and draw around the stencil or apply the paint directly, preferably with a stippling brush.

Chalking

This is a technique that can give extra colour, dimension or softness to your cards. There are various chalks available from craft shops either individually in small blocks, as a chalk pad or as a palette with a selection of chalks.

You will need

chalk pad or palette
cotton wool ball or sponge-tipped
applicator

Using chalk

Chalks can be applied to your card in different ways to create different effects. Use a cotton wool ball to give the background paper or card a dusting of colour, which can be evenly or unevenly

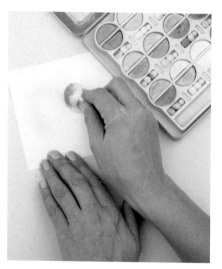

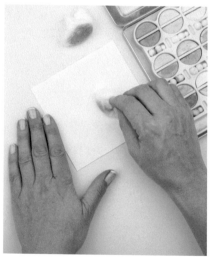

1 Place the cotton wool ball onto the chalk and lightly twist to load it with colour.

2 Apply it to your card using a gentle circular motion, brushing off any excess. If necessary, the chalk can be sealed using an aerosol hairspray.

distributed over the card depending on what finish you want. Alternatively, use a special sponge-tipped applicator, which has an alligator clip to hold small cotton wool pompoms (or use an eye-shadow applicator).

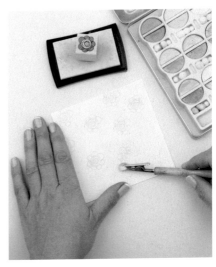

3 To create an image, stamp or draw your design onto the card using a watermark ink pad or pen and then apply chalk directly on top to colour it in.

4 It is best to apply the chalk lightly to start with and then add more colour if required, blending together the colours.

Peel-offs

Peel-offs are so easy to use and are widely available. They come in a variety of colours, images and messages, borders and corners. Use them to add decorative details to your cards.

Using peel-offs

Peel-offs can be the main feature of your card (e.g. the elephant on the card on page 98 is a peel-off, which has been coloured in), or embellishments for your card, e.g. flowers, hearts, stars, numbers and messages can be used on the outside or inside of your card. They are delicate, so take care when handling them.

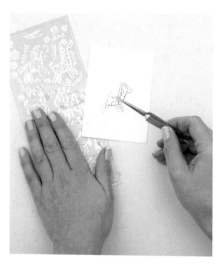

1 Use the tip of a scalpel or tweezers to lift a peel-off from its backing sheet.

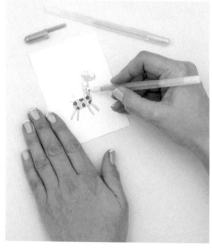

2 Stick it onto the card and leave as it is or colour it in using paint or a gel pen.

3 Border peel-offs are a very versatile addition. Stick down over the edge of the card and then trim to fit.

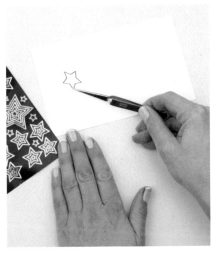

4 To use a peel-off as a stencil, first stick the design of your choice on the backing card.

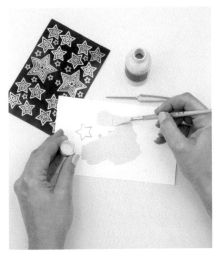

5 Apply a layer of paint over and around the peel-offs.

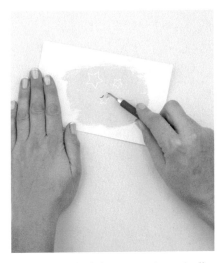

6 Once the paint is dry, remove the peel-offs from the background to reveal their outlines.

Paper punching

Paper punches are available in many shapes and sizes. They can be used to produce shapes to use as embellishments, such as the flowers on the card on page 86. Other punches come in shapes such as squares and circles, which can be used to give your card added dimension or to create your own apertures.

Using paper punches

Use corner and border punches to decorate your cards. These can be patterned as shown on the cards on pages 112 and 130, or a plain corner-rounding punch, which just gives the corners a neat, professional finish, as shown in the card on pages 98 and 122.

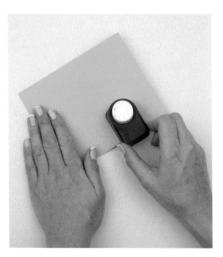

1 Take the card or paper and slide it into the paper punch.

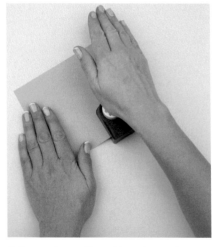

2 Ensure the card is positioned correctly before you press the punch with the heel of your hand.

Useful tips

- You can decorate punched shapes with chalk or pens (for example, see pages 136 and 151) to give added colour.
- If using a punch to produce shapes for your card, the shapes can be arranged on your card and stuck in place with adhesive.
- If your punch is sticking, punch into some waxed paper, and if it has become dull and the cutouts have furred edges, punch into aluminium foil to sharpen the cutting action.

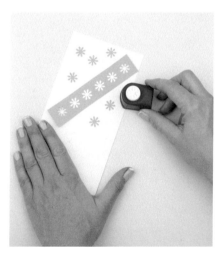

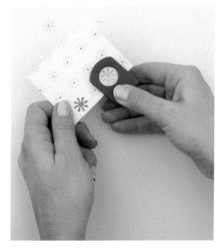

3 With some punches, the negative of the image is just as attractive as the positive image – double the value.

4 It is possible to punch upside down with some punches so you can see where the shape will be cut.

Setting eyelets

Eyelets are decorative metal fasteners that are made of aluminium and other metals and come in a large variety of colours, sizes and shapes. They are cylindrical with one end rolled over so there is no sharp edge on the front or back.

You will need

pencil
eyelet setter kit
eyelets
tweezers

Using eyelets

The eyelet is passed through a hole in the card and the piece of work reversed so that the back of the eyelet can be flattened using a setting tool. These

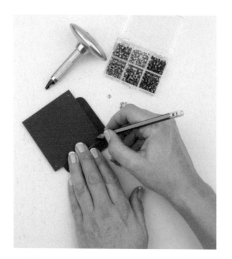

1 Place your open card flat on a cutting mat using a hard work surface. Mark the positions of the eyelets required with a pencil.

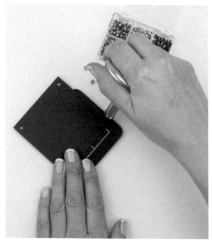

2 Using the hole punch that corresponds to the size of the eyelet, make holes where your pencil marks are.

holes made by the eyelets can be used purely for decoration or can be used to thread ribbons (see card on page 112) or to attach vellum (see card on page 176) to your card where gluing isn't possible.

Useful tip

The traditional eyelet hole punch and setter require the use of a hammer to make the hole and set the eyelet. This method can be very noisy and there are now kits available in craft shops featuring a hole punch and setter that uses a method of firm pressure and rotation action.

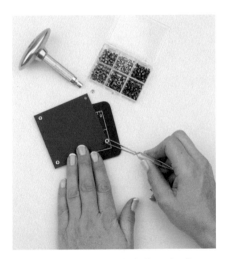

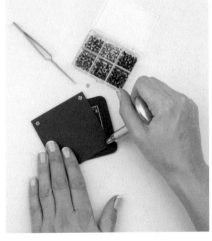

3 Place the eyelet in the hole from the front of the card and then, holding it in place, turn the card over and lay it face down on the cutting mat.

4 Take the eyelet setter that corresponds to the size of the eyelet and place the tip into the top of the eyelet shaft. Set your eyelet so that the edges of the eyelet shaft roll back and lie flat against the paper.

Using brads

These are also known as paper fasteners and, like eyelets, come in a huge variety of sizes, colours and shapes, including circles, flowers and hearts. They are very easy to attach to a card and they allow movement and dimension.

You will need

pencil
hole punch
scissors (optional)
brads

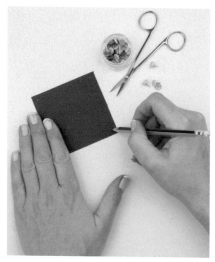

1 Mark the position of each brad with a pencil. Here a brad will be fixed to each corner.

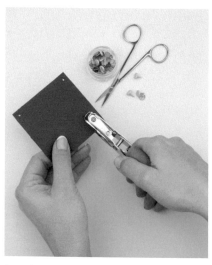

2 Make a hole in the card where your pencil mark is using a small hole punch. If you then need to enlarge the holes, use the point of a fine pair of scissors.

Useful tips

- When making a hole in the card for your brad, you can use a paper piercer or needle instead of a hole punch.
- For ideas for using brads, see A woman's best friend on page 80, where a brad is used to attach the handbag to the card, which allows the bag to swing.
- See also Thinking of you on page 176, where brads have been used to attach vellum to the card. They are especially useful here as adhesive shows through such transparent papers.

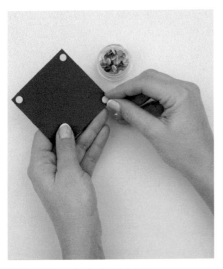

3 Carefully push the brad right the way through the hole.

4 Turn the card over and carefully fold back the fasteners.

Iris folding

This is a paper-folding technique originating from Europe and is so named because the finished designs resemble the iris of an eye or lens of a camera.

You will need

coloured paper
scissors or paper cutter
bone folder (optional)
iris folding design
masking tape

So that this design is easier to use, enlarge it on a photocopier by 120 per cent.

Starting iris folding

The art of iris folding is much more straightforward than it looks. It simply uses colour-coordinated strips of paper in as few or as many colours as you like (here there are four, although only three are used in the main design), which are folded and taped in place over a template to create a spiralling design, focusing on a central point. A wide variety of aperture card blanks are available for use with iris folding (see pages 14–15 and 187).

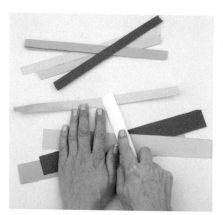

1 Choose the paper that you want for your design and cut into 2.5cm wide strips. Fold the paper strips in half, making sure the creases are firm. Use a bone folder if you have one.

2 Cut an aperture in the card to match the iris design. Place the aperture over the design pattern sheet with the wrong side facing you. Use masking tape to stick this in place.

3 Place the folded paper strips over the design pattern sheet in strict order. Beginning with colour 1, tear off an appropriate length and stick in place with small pieces of masking tape. For a good finish, ensure the crease faces the centre of the aperture.

4 Do the same with colour 2 ...

5 ... and then with colour 3. Continue working around the design repeating colours 1, 2 and 3.

6 At the end, there will always be a small hole left in the centre. Cover this with a small piece of card in any colour you like and then back the whole design with a piece of card.

Teabag folding

The technique of teabag folding originated in Holland when a Dutch crafter was playing with the envelopes that hold fruit teabags, and then used these creations to decorate cards. It involves simple origami techniques, and tiny squares of patterned paper are combined to form a larger motif.

You will need

teabag papers (bought or homemade)
scissors
folding instructions
PVA adhesive or double-sided tape

Starting teabag folding

There are many kits for teabag folding that you can buy. They come complete with pre-printed designs ready to be cut out, and folding instructions. This is one of the simplest designs around – for making something a little more complicated see page 170.

1 Cut out an appropriate number of patterned squares for the design you are following – here there are eight of them.

2 Follow the folding diagrams (for this card they are given above opposite) to create a set of simple shapes.

Place each paper square face down and fold in half diagonally. Open up and fold in half vertically.

Fold in half again so that the crease is on the top.

Always fold the squares in the same direction to ensure an identical part of the pattern shows on the top.

3 Stick the folded squares together using either double-sided tape or PVA adhesive. Make sure the folds on the shapes always face the same direction and are correctly aligned.

4 Continue sticking the squares together until you have the finished piece. Tuck the last square in behind the first.

Quilling

Quilling is so called because when it was first done, the strips of paper were wrapped around goose quills. The basic principle is very straightforward and once you have mastered it you will be able to quickly make all sorts of different shapes.

Starting quilling

Quilling is the process of rolling narrow strips of coloured paper, which you can buy in packs of assorted colours, around a quilling tool to make paper coils and spirals. These shapes can be pinched into other shapes such as teardrops, triangles or squares and then stuck to card to form a picture. The quilling tool is a stick with a slit in one end.

You will need

quilling paper
scissors
quilling tool
PVA adhesive
cocktail stick

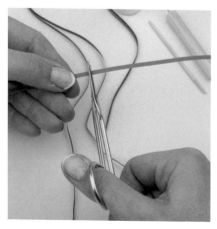

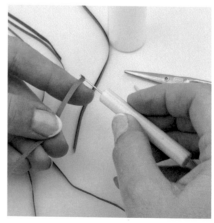

1 Cut a narrow strip of paper to approximately the required length (which will depend on the finished size of the quill).

2 Take the quilling tool and slot the paper through the slit and start to twist, keeping the coil tight.

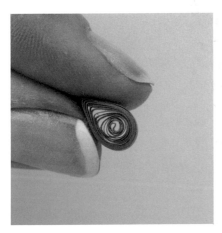

3 Remove the coil from the quilling tool and allow the coil to loosen slightly (to required size). If you are making a teardrop shape, pinch the coil to form the relevant shape, ensuring the end of the paper is at the top of the teardrop so that you won't see it once glued.

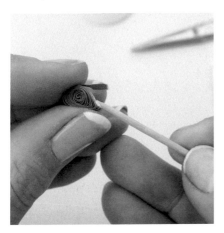

4 Glue down the end of the paper. Only a dot of glue is required and it is best applied with a cocktail stick.

Different quilling shapes

Basic coil: coil a strip of paper but do not pinch or shape it.

Diamond: pinch the coil at both ends.

Triangle: pinch the coil into a triangle with fingers and thumbs.

Square: pinch the coil into a square with fingers and thumbs.

Spirelli

This technique involves winding thread around a die-cut shape to create beautiful geometric designs. Lengths of thread are wound around the template to give a spiral motif with a gap in the centre. This focal point can be left blank or decorated.

You will need

spirelli templates
thread or wire of your choice
masking tape
scissors

Starting spirelli

You can buy ready-made spirelli templates or make your own with deckle-edged scissors. The thread is wound around the template or card, always leaving the same number of notches.

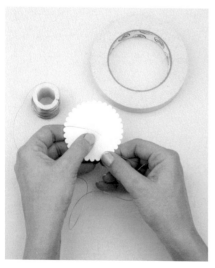

1 Stick the end of the wire to the back of the spirelli template with a piece of masking tape.

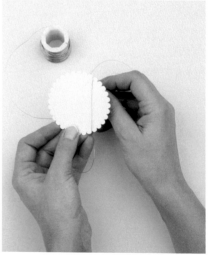

2 Bring the wire over to the front of the template (here, ten notches have been left between each wrap of the wire) ...

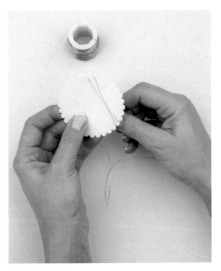

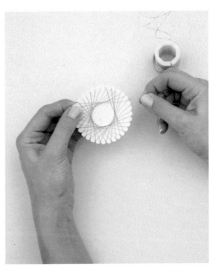

3 ... then take it to the back and around over the front again, one notch to the right.

4 Continue wrapping the wire around the template until every notch is covered.

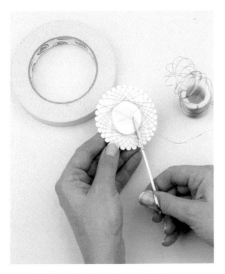

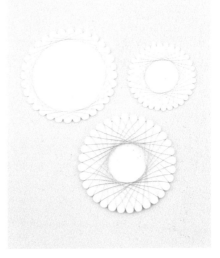

5 To finish, stick down the end with some more masking tape and trim to neaten.

6 The size of the hole in the centre and the finished pattern created by the thread depends on how many notches you leave between each wrap of the thread.

Wire and bead work

Wire and beads are always useful embellishments to have in stock. They can be used separately or together to add colour and variety of texture to your card designs.

You will need

scissors
(decorative-edge
and standard)
wire and beads
masking tape

Making a wire and beaded panel

Thin craft wire, also called beading wire, comes in different colours and thicknesses and is very easy to use as it is so pliable. Keep an eye out for small beads which are always available in shops in all manner of shapes, sizes and colours – you could even buy some very cheap necklaces and take them to bits. Store them in separate containers for ease of use.

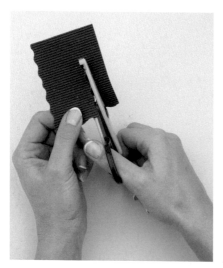

1 Cut out a piece of card to whatever shape you want. Use decorative-edged scissors (here we used a wave-edged design) because this will help keep the wire in place.

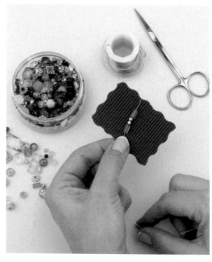

2 Cut a length of wire long enough to wrap around the panel a few times. Attach the end of the wire to the back of the card with masking tape.

Useful tips

- Pegboards are available for winding wire around. If you find you enjoy using wire on your cards, you might decide to buy one of these to make your work even more varied.
- Likewise, a wire writer – a pen that dispenses wire – can speed up your work.
- You can also use this type of pen to write words with your wire.

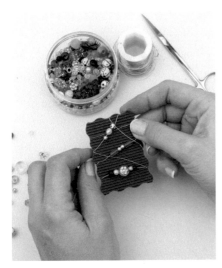

3 Continue to wind the wire around the panel and then start threading on beads.

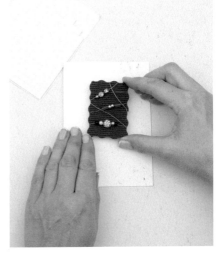

4 Attach the panel to your card using several foam pads.

Shrink plastic

Shrink plastic is available at many craft shops and consists of sheets of white, black, clear or milky plastic, which are shiny on one side and rough on the other. It is the rough side that you decorate and you can use any permanent ink pens you like.

You will need

shrink plastic
stamp and ink pad
 (optional)
permanent ink
 pens
scissors
hole punch
heat gun

Using shrink plastic

When heated either in an oven or with the use of a heat gun the image shrinks and becomes seven times smaller than it was originally. If the colour isn't very intense when first applied, don't worry because as the plastic shrinks, so the colours become stronger – seeing the plastic diminish so quickly and the colours intensifying is quite extraordinary. You can use your shrunk plastic to make embellishments for all sorts of things, ranging from badges and fridge magnets to jewellery and key rings, as well as cards.

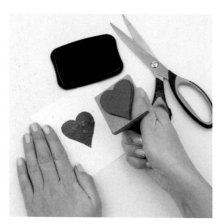

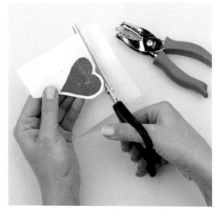

1 Using a coloured ink pad, stamp your chosen image onto the rough side of the shrink plastic and allow to dry. Or use permanent ink pens to draw and/or colour in an image.

2 Cut out your stamped image leaving a 3mm border all around it.

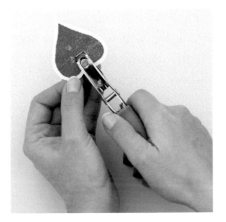

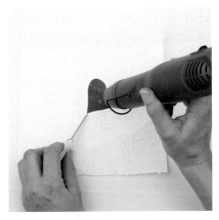

3 If required, punch a hole at the top of the image. This is necessary if you are going to attach a key ring or hang your image on a card. The hole cannot be made after the image is shrunk.

4 Heat your image with a heat gun and allow to shrink. This will take a few seconds depending on the size of your image.

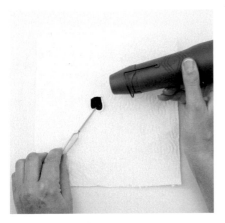

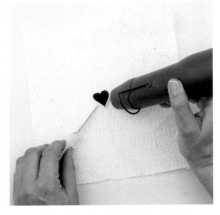

5 During the process, the image twists and curls and it can look like your handiwork is going wrong.

6 But when fully shrunk, the shape lies flat and then sets hard. Alternatively, the image can be put in the oven for a few minutes at 180°C (350°F/Gas mark 4).

Cross stitch

Cross-stitch card kits are available in many craft shops, but if you want to design your own, this is relatively straightforward. Use the squares on a piece of graph paper to represent each stitch. If you want to include French knots, use dots, and for back stitch, use lines.

Working a cross-stitch design

The fabric most commonly used is an Aida or an even weave linen fabric. Aida fabric is an even weave fabric that has the same number of blocks of thread horizontally and vertically, and is usually referred to by the number of threads per inch. A 36-count even weave fabric will produce 18 cross stitches to 2.5cm (1in) as the stitch is worked over two threads.

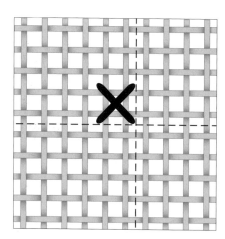

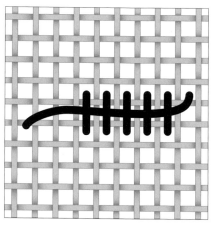

1 Centre the design by finding the centre of your fabric. Fold the fabric in half horizontally and then vertically. The point where the two lines cross is your central point. Find the centre point of the design and start stitching from here, working outwards.

2 Embroidery thread consists of six strands but cross stitch is generally worked using two strands, while back stitch and French knots are worked using one strand. Start by leaving a short length of the thread hanging loose at the back of the work and oversew it as you work.

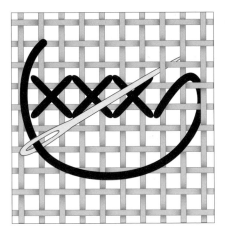

3 For neat cross stitches, always make sure the bottom stitch falls in the same direction.

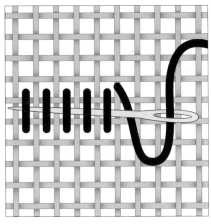

4 To finish off a strand, pass it underneath a few stitches on the reverse of the work.

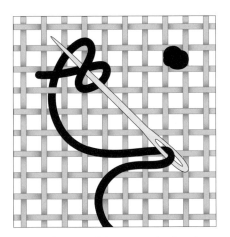

5 To make a French knot, wrap the thread over the needle in a figure-of-eight, pull the needle through and then pass through the fabric to the back, pulling tight.

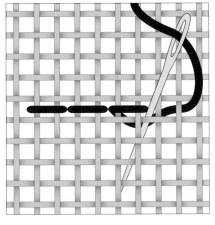

6 To work back stitch, start by making one running stitch, then bring the needle back up to the top, two holes further along. Pass the needle one stitch back. Repeat as often as is required by the chart.

3 Birthday cards

This chapter starts with birthday cards for ladies, which all feature flowers, shoes or handbags – what more could a girl want? Next it looks at cards for men, and then children. Any of these cards can be made exactly as shown or adapted in whatever way you choose. For example, card colours, paper punches or rubber stamp images can all be exchanged for those in your own collection.

Petals with a punch

The delicate finish of this card is partly due to the pearlised card that has been used as the background and the flowers, but it is also thanks to the layering of the petals. When you buy some new paper punches it is worth getting the same design in different sizes because then you can use them in many combinations.

You will need

dark pink pearlescent
single-fold card
(112 x 112mm)
white card
(100 x 100mm)
dark and light pink
pearlescent card
(scraps)
pink chalk pad and
sponge
grid stencil
paper trimmer or
scissors or cotton
wool
paper punches
(small and medium
flower)
PVA adhesive
4 gems (2 white,
2 pink)

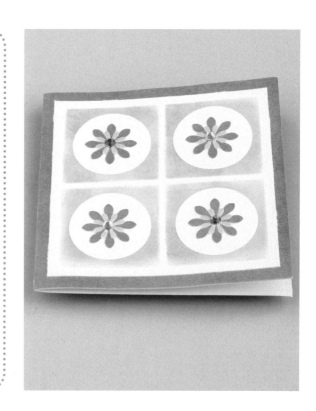

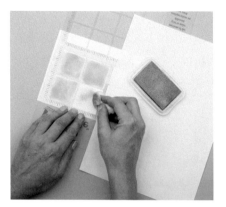

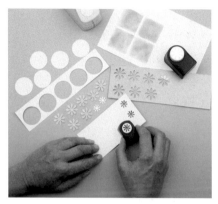

1 Using a piece of cotton wool, apply pink chalk to the white card through the grid stencil. Using the paper trimmer or scissors, cut the card so that it is marginally smaller than the main piece: 100 x 100mm. Save the off-cuts.

2 Punch circles from the saved pieces of white card, larger flowers from the dark pink pearlescent card and smaller flowers from the light pink pearlescent card.

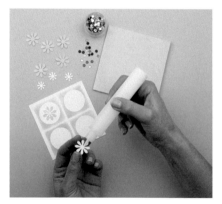

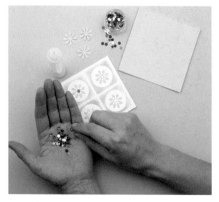

3 Using the adhesive, stick each circle into the centre of each pink chalky square. Then stick the large flowers in the centre of each white circle and top off with the small flowers, ensuring the petals fall between those of the larger flowers.

4 To finish off each flower, stick a gem into the centre, alternating the pink and white.

Stylish heels

One paper punch, plenty of variety. By flipping and rotating a punched out shape, you gain lots of design potential – and don't forget to use different papers, too, as for this card. If you know the recipient has a favourite colour, use it!

You will need

silver single-fold card (112 x 112mm)
pale pink card (108 x 108mm)
silver card (95 x 95mm)
pale pink card (75 x 20mm)
pale pink and black card (scraps)
paper trimmer or scissors
paper punches (shoe and 15mm square)
PVA adhesive
rubber stamp (message of your choice) and black ink pad or fine
 black pen

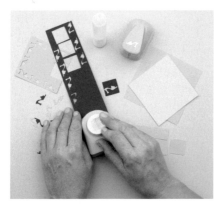

1 Punch out a selection of pink and black shoes and also punch out three pink and three black squares.

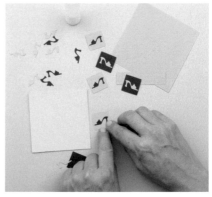

2 Stick a pink shoe onto each of the black squares and stick black shoes onto each of the pink squares.

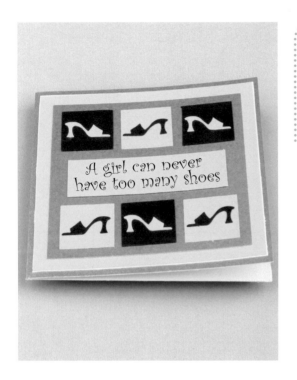

Useful tips

- If you don't have a square punch, you can quite easily cut out these backgrounds for the shoes using scissors.
- It looks very smart if all the pink shoes face one direction and all the black ones face the other. Play around with other combinations to see what you like the look of the most.

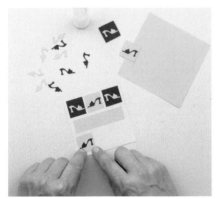

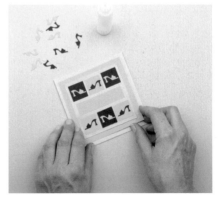

3 Then stick the squares onto the silver background card and add the strip of pale pink card to the centre.

4 Mount the whole decorated silver square onto the pink square and then stick onto the silver main card. Apply the message of your choice using the stamp and black ink pad or fine black pen.

A woman's best friend

The decorations on this card have been made from reversible paper, of which there is a wide selection on the market. The advantage of using paper like this is that you will always be able to guarantee a good colour match for the different elements of your design.

You will need

white single-fold card
(105 x 148mm)
background paper (98 x
142mm, plus extra for
decorations)
paper trimmer or scissors
PVA adhesive
photocopy of bag
template
bone folder
corner paper punch
beads
100mm waxed thread
brad
rubber stamp (message of
your choice) and black
ink pad or fine black
pen

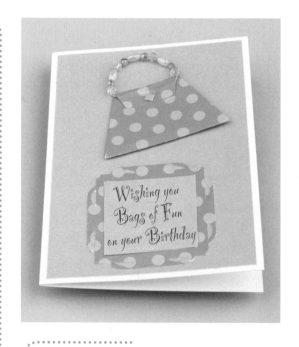

Useful tips

• Instead of using reversible paper, you could use two contrasting ones.
• Waxed thread holds its shape well and is easier to fix in place than wire.

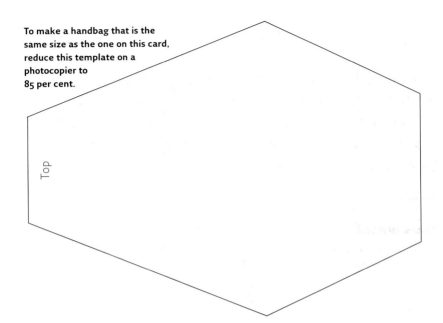

To make a handbag that is the same size as the one on this card, reduce this template on a photocopier to 85 per cent.

Top

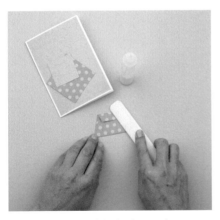

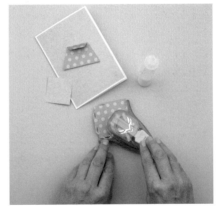

1 Cut a rectangle of the background paper slightly smaller than the main card and stick in place. Cut out the bag template and draw around it onto the back of another piece of the background paper, and cut out. To turn into the handbag, fold edge A along the dotted line. Then fold over the top and press firmly with the bone folder.

2 Cut out two small squares from the background paper, one slightly larger than the other. Use the corner paper punch to cut decorative corners on the larger of the two. Stick on the main card.

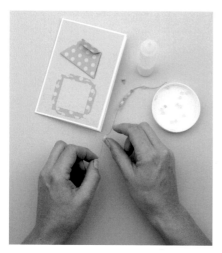

3 To make the handle of the handbag, thread a variety of beads onto the waxed thread.

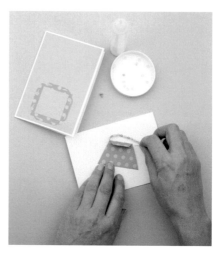

4 Feed the ends of the handle underneath the top flap of the handbag.

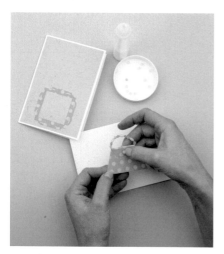

5 Push a brad through all the layers to keep the handbag closed (see pages 58–9), but do not open out the back of the brad.

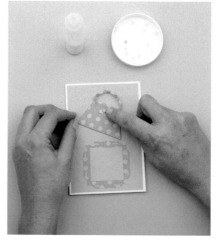

6 To finish the card, make a hole in the main part and push the brad through, opening on the reverse. The handbag is then free to swing.

Self-raising flowers

It is always worth having some acetate in your collection of card-making materials. It can be used as windows in apertures, for making your own stencils (see pages 48–9) and, as here, as a part of the design itself. Fine glitter has been stuck to the acetate, creating a pretty, glistening finish.

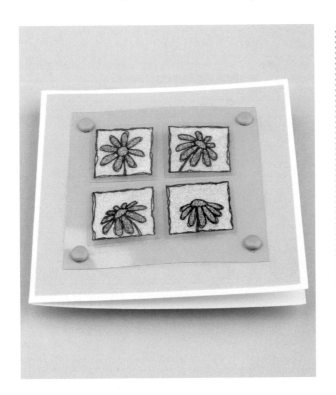

You will need

white single-fold
 card (130 x
 130mm)
pink card
 (124 x 124mm)
acetate (95 x 95mm,
 80 x 80mm)
paper trimmer or
 scissors
ink pad (black)
rubber stamp
 (4 flower images)
glitter glue
 adhesive with
 fine applicator
fine glitter (white,
 pale blue, pink)
4 brads (pink)
hole punch
foam pads

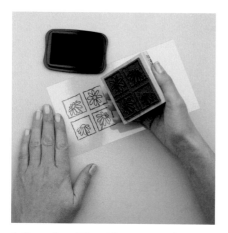

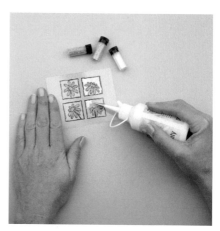

1 Stamp four different images onto the smaller acetate square using black ink (see pages 40–1). You could either use one large stamp, as here, or four separate ones. Alternatively, draw your own designs onto the acetate using indelible ink.

2 The glitter colours need to be applied one by one to the reverse side of the printed acetate. Fix the fine applicator to the glitter adhesive and carefully apply glue to the area to be glittered. Here, the pink glitter has already been stuck down and the glue is being applied to the areas where the white glitter will be scattered.

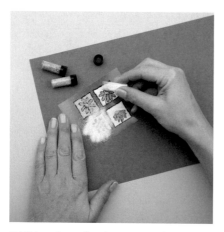

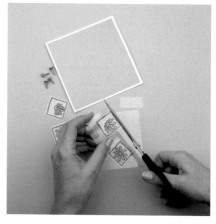

3 With a piece of card or paper underneath the acetate, sprinkle generous amounts of the glitter onto the glued areas of the acetate. Tip off the excess and leave the glittered acetate to dry. This can take up to an hour.

4 Cut the decorated acetate into individual squares and discard any spare pieces of acetate (or store for future use).

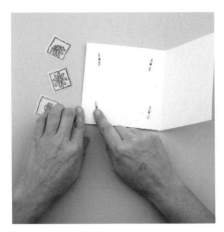

5 Fasten the large, undecorated, acetate square to the main card with a brad in each corner (see pages 58–9). Open the brads out flat on the reverse side.

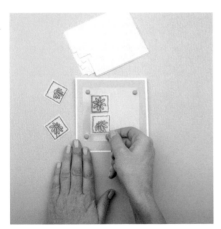

6 Stick each of the decorated acetate squares to the large piece of acetate with a single foam pad in the centre of each.

Useful tips

● The glitter glue goes on white, but dries clear.

● If you don't want the backs of the brads showing, you can always cover them with another piece of card.

● If you just have a single flower rubber stamp that you would like to use, you could consider turning the image around for each acetate square to give some variety.

Flower power

This card can be readily adapted to make it more suitable as a birthday card for a man – choose a different background paper and replace the flowers with, say, a football or car.

You will need

white card
 (295 x 210mm)
patterned background
 paper (145 x 208mm)
olive green card
 (35 x 204mm)
white card
 (20 x 192mm)
pink and olive green
 card (scraps)
paper trimmer or scissors
bone folder
glue stick
4 brads (2 pink,
 2 olive green)
hole punch
rubber stamp (message
 of your choice) and
 black ink pad or fine
 black pen

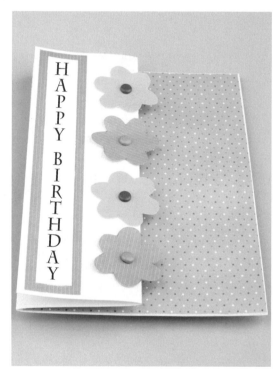

Either photocopy this template and use it at this size or enlarge or decrease it to suit your design.

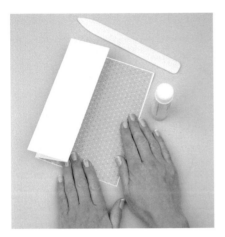

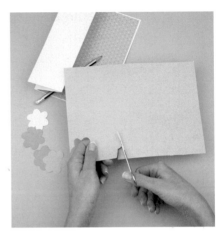

1 Fold the white card to make a concertina opening. Ensure the back of the card is wider than the fold in front. Stick down the patterned background paper.

2 Draw a simple flower shape on scraps of pink and olive card (or use the outline, opposite) – two on each one. Cut them out.

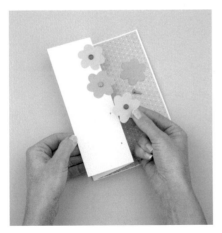

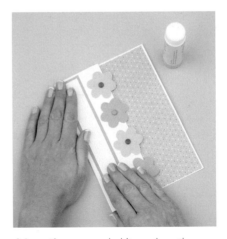

3 Attach the cut-out flowers to the edge of the front fold using the brads (see pages 58–9) and pushing them through both layers of the paper.

4 Layer the green and white cards on the front of the main card and then apply the message of your choice using the stamp and black ink pad or fine black pen.

Spots

This handsome design makes play of using variations on a single colour. It would be interesting to see what the same design looks like with the occasional splash of bright colour or by adding some sparkling embellishments to the centres of some of the circles.

You will need

metallic silver single-fold card (100 x 210mm)
black card (90 x 30mm)
white card (78 x 17mm)
white, black and patterned card (scraps)
paper trimmer or scissors
paper punch (small circle)
PVA adhesive
hole punch
4 silver eyelets and eyelet setter
cutting mat
rubber stamp (message of your choice) and black ink pad or fine black pen

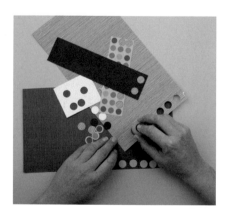

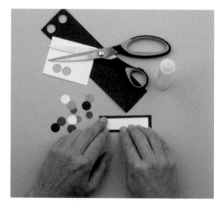

1 Using the small circle paper punch, cut out plenty of circles from the white, black and patterned card.

2 Stick together the two layers of card that the final message will be printed on.

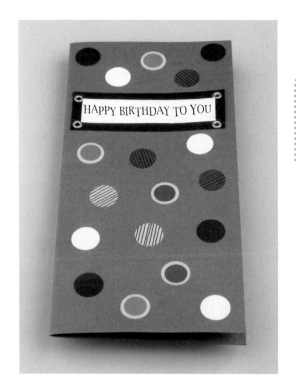

Useful tip

If you find paper with circles ready printed and cut them out with some of the background surrounding each circle, you get a ready-made double-layered effect.

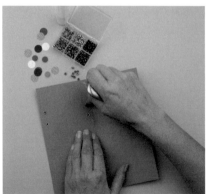

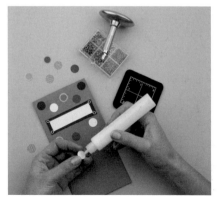

3 Position the message area on the main card and attach using an eyelet in each corner (see pages 56–7).

4 Stick your cut-out circles randomly over the front of the main card. Apply the message of your choice using the stamp and black ink pad or fine black pen.

Hot wheels

There are lots of different chalk collections available, ranging from pastel to bright colours. Use chalk to add patches of soft colour as backgrounds and frames to your cards. It can be readily stamped and drawn over. Just one word of warning – chalk can smudge so take care not to rest your hand on the surface.

You will need

pearlescent blue
single-fold card
(125 x 125mm)
white card
(110 x 110mm)
grid stencil
chalk (blue)
cotton wool balls
rubber stamp (car)
ink pad (clear
watermark)
applicator tool
paper trimmer or
scissors
PVA adhesive
rubber stamp
(message of your
choice) and black
ink pad or fine
black pen

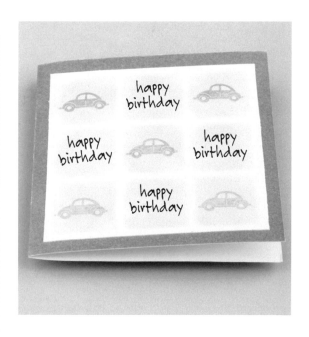

Useful tips
● Apply the chalk and stamp before cutting down the card to size.
● If you leave the ink too long before chalking, the ink will dry and so the chalk won't apply.

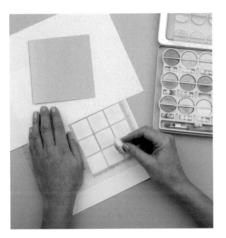

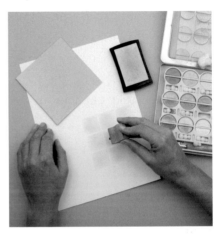

1 On the uncut white card, use a make-up sponge to apply blue chalk through the grid stencil. Fill in nine squares to make a three-by-three grid. Remove the grid.

2 Use the rubber stamp to apply clear ink to the grid on as many of the squares as you want to decorate.

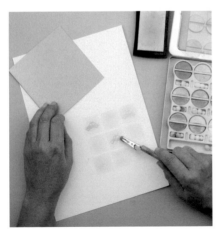

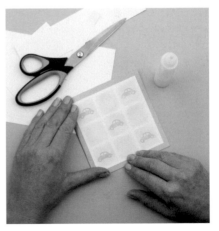

3 Immediately, use the applicator tool to apply a darker shade of blue chalk onto the clear ink (see page 51).

4 Cut the white card down to size and then stick to the blue background. Apply the message of your choice using the stamp and black ink pad or fine black pen.

Good shot

This is the perfect card for customising – check up on the recipient's favourite football team and then ensure you colour in the card to match the players' strip.

You will need

white single-fold card
 (128 x 178mm)
dark green card
 (75 x 115mm, 53 x 30mm)
pale green card
 (68 x 110mm, 25 x 48mm)
white card (43 x 20mm)
paper trimmer or scissors
rubber stamps (footballer
 and football)
ink pad (black)
clear embossing powder
heat tool
crystal lacquer pens (red,
 pink, brown, black)
small detail scissors
foam pads
PVA adhesive
rubber stamp (message of
 your choice) and black ink
 pad or fine black pen

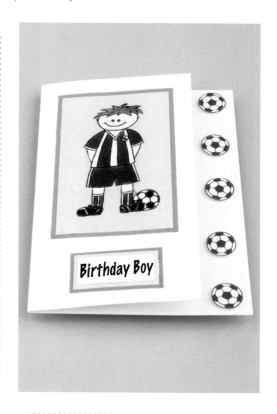

Useful tip

It is best to use crystal lacquer pens on an embossed image as this helps to contain the colours and prevent bleeding.

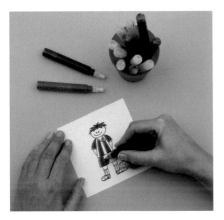

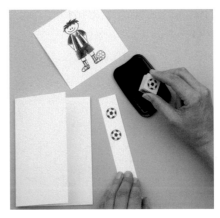

1 Follow the embossing technique on page 44 to create the outline on white card. Fill in the image with the crystal lacquer pens, letting each colour dry before working on an adjacent area.

2 While you are waiting for the crystal lacquer pen colours to dry, use the black ink pad and football stamp to make five football stamps on a spare strip of white card. Cut out the footballs.

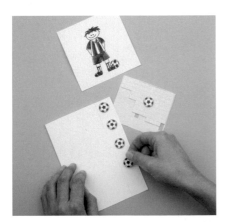

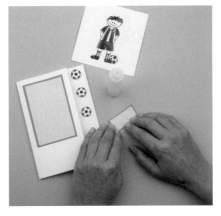

3 Cut off a narrow strip from the front of the main card. On the resulting display area, stick the footballs in place using foam pads.

4 On the front of the main card, layer all the coloured pieces of card, as shown in the photograph. Then cut out the footballer and stick in place. Apply the message of your choice using the stamp and black ink pad or fine black pen.

Spot the dog

Creating a card design from simple shapes is especially satisfying. Use squares, triangles and circles (or other, freer shapes, if you prefer or if your design demands it) and piece them together to make whatever picture you have designed. See the Roving robot on page 102 for another card using this approach.

You will need

black single-fold
 card (135 x 135mm)
blue card (125 x
 125mm)
white, black and
 blue card (scraps)
paper trimmer or
 scissors
glue stick
paper punch (small
 circle)

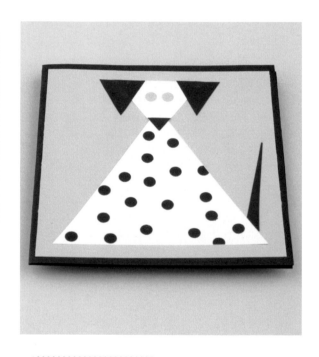

Useful tip

It looks good to have a few half spots at the edges of the white body, trimming them to fit before you stick them down.

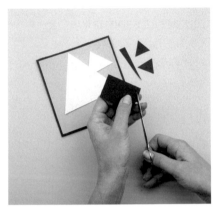

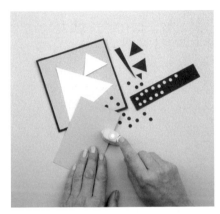

1 Stick the blue square to the front of the main card. From the white card cut out one large triangle and one small triangle. From the black card, cut two matching triangular ears, a tiny nose and a long, elegant tail.

2 Using the paper punch, cut out lots of black dots for the dog's body and then two blue dots for the eyes.

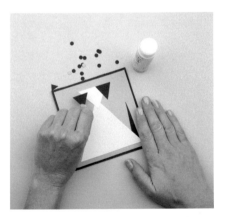

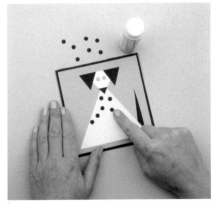

3 Start sticking the pre-cut shapes together. Start by gluing the big white triangle that forms the dog's main body towards the foot of the card. Then add the tail. For the head, first stick on the small triangle, followed by the ears, nose and blue eyes.

4 Finish the card by sticking on the dog's spots, scattering them all over.

Puffing train

This card is made from an iris folding kit (see page 191 for supplier). Such kits are readily available from craft shops and via mail order and it is always fun to add your own finishing touches, as here. For a simpler project to make yourself, see the iris folding information on pages 60–1.

You will need

pre-cut card and
 iris folding
 diagram (for a
 simpler design,
 see page 60)
white card to cover
 back of work
silver card (a scrap)
strips of paper (red,
 green, yellow,
 blue) cut to
 width of 25mm
 (1in)
paper trimmer or
 scissors
masking tape
acetate
black pen
cutting mat
craft knife or small
 scissors
chalk (grey)
applicator

Making a stencil

When making a stencil it is best to use a transparent material, such as acetate, so that you can see where you are positioning it. If you find a craft knife difficult to work with or you don't have one, a small pair of scissors is just as good for cutting out the image.

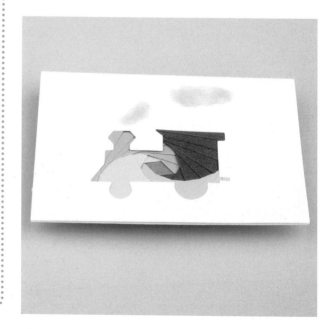

1 See pages 60–1 for iris folding techniques – these can be applied to any pre-cut card. Here, red strips are followed by green, then yellow and then blue. Repeat the sequence until the entire chart is covered. Cover the remaining central hole with the small piece of silver card.

2 To make the cloud stencil, draw two little cloud outlines on the acetate. To get a good scale and positioning, place the acetate on the front of the card.

3 Using the craft knife and cutting mat, carefully cut out the two clouds.

4 Use grey chalk and an applicator to create soft clouds coming out of the train's funnel.

Pink elephant

Peel-offs are available in all sorts of different images as well as messages, numbers and borders. Keep a good supply of them in your craft collection.

You will need

pink pearlescent single-fold card (127 x 127mm)
white card (110 x 110mm, 65 x 65mm)
pink pearlescent card (77 x 77mm)
paper trimmer or scissors
corner paper punch
peel-off (elephant)
tweezers
soufflé pens (grey, pink)
rubber stamp (small circle)
ink pad (clear watermark)
chalk (grey)
applicator
PVA adhesive

1 Cut the corners from all the layers and the main card using the corner punch.

2 Choose the peel-off that you would like to use and stick to the central piece of white card. Colour in with the soufflé pens and then leave to dry.

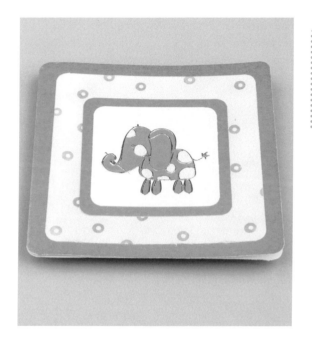

Useful tips
- Soufflé pens tend to start off much darker than the colour that they dry to. Don't be alarmed! They also take about 10 minutes to dry.
- If you don't have an applicator for the chalk, cotton buds are just as good.

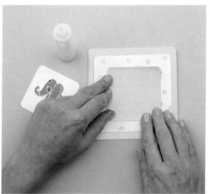

3 Meanwhile, decorate the background paper by rubber stamping small circles in clear ink and dusting chalk over the top using the applicator (see page 51).

4 Piece together the card as shown above, sticking the layers together one by one.

Sew angelic!

If you enjoy sewing, then this is the card for you. There are plenty of books out there with cross-stitch images for you to use in your designs, or why not create your own? It's not difficult. All you need is some squared paper and colouring crayons.

You will need

ready-made cream
 double-fold card
 with aperture
 (143 x 143mm)
cream Aida
 (120 x 120mm)
angel chart
embroidery thread
 (various colours)
needle
sewing scissors
double-sided tape
PVA adhesive
silver stars (punched
 or stickers)

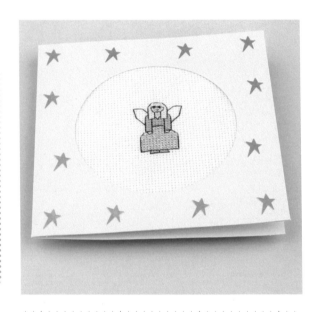

Key

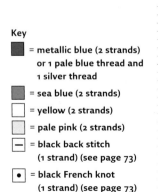

= metallic blue (2 strands)
 or 1 pale blue thread and
 1 silver thread

= sea blue (2 strands)

= yellow (2 strands)

= pale pink (2 strands)

= black back stitch
 (1 strand) (see page 73)

= black French knot
 (1 strand) (see page 73)

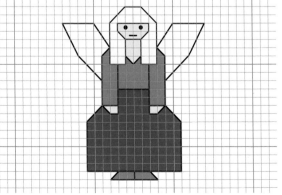

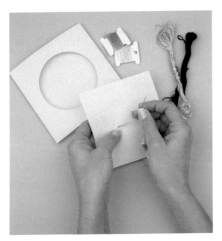

1 Using the chart opposite and following the instructions on pages 72–3, sew the image in cross stitch.

2 On the reverse side of the aperture, stick a strip of double-sided tape around each edge. Peel off the backing on the tape.

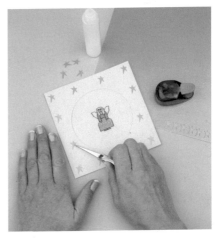

3 Turn the image face down and position over the aperture so that the picture is centred. Press down firmly on the double-sided tape and then stick down the inner flap.

4 To decorate the front of the card, stick down silver stars in a random pattern.

Roving robot

Like Spot the dog on page 94, this has to be the simplest of ideas for a card – and so effective, too. To vary the design, you could consider adding a speech bubble with a birthday message, have the robot hold something or add a football that he is about to kick. Your cards don't have to match these ones exactly.

You will need

white single-fold card
 (128 x 178mm)
red card panel
 (124 x 176mm)
silver and black card
 (scraps)
paper trimmer or
 scissors
paper punch (small
 squares) (optional)
PVA adhesive
tweezers

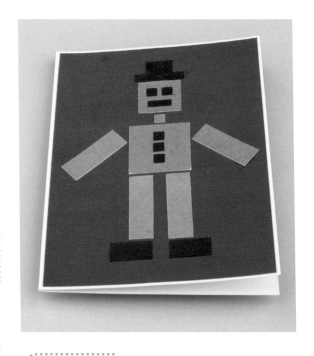

Useful tip

If you find it difficult to cut out small squares accurately, there are paper punches available to help you.

1 Cut out the red card panel and the various robot pieces, following the finished card picture, opposite.

2 Stick the red panel to the centre front of the main card and then position the silver pieces of card for the robot's head and body.

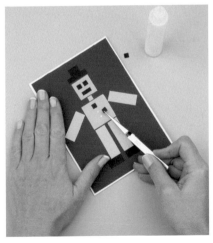

3 Then stick on the hat pieces and the feet ...

4 ... and finally the robot's buttons and face. Tweezers can be very helpful for positioning small details such as this.

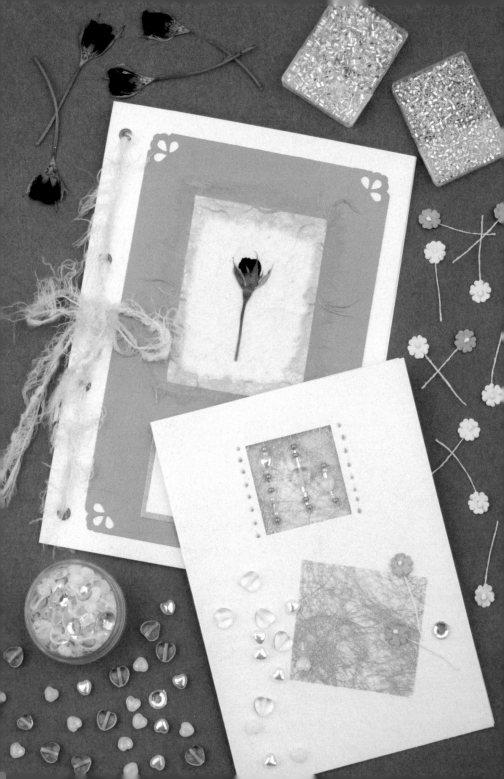

4 Cards for weddings and anniversaries

This is the chapter of beads and flowers. Whether you are designing your own wedding invitations or making a card to give to a happy couple to celebrate their wedding day or an anniversary, you will find plenty of ideas within this section. Of course, if you are particularly taken by one of the designs but don't have a wedding or anniversary to celebrate, then adjust it to whatever occasion you like.

The happy couple

This design uses a pre-cut stencil as a template. There are many such templates available (see page 24). Alternatively, draw your own clothing items. You can use this idea for creating all sorts of different cards with a variety of papers and shapes.

You will need

white card
 (295 x 210mm) folded
 into a gatefold card of
 148 x 210mm
black card (70 x 208mm,
 64 x 198mm plus
 scraps)
white pearlescent card
 (70 x 208mm,
 64 x 198mm plus
 scraps)
template (dress and
 suit) or own design
cutting mat
craft knife
paper trimmer or
 scissors
PVA adhesive
1 gem (crystal)
tweezers
silver ribbon
paper flowers

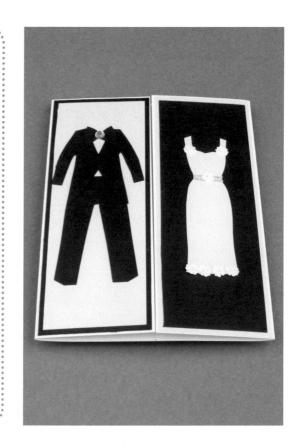

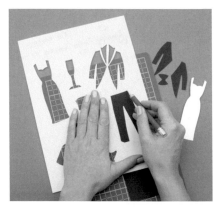

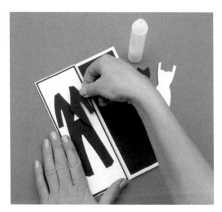

1 Using the stencil template, craft knife and cutting mat, cut out each of the suit and dress items in black and white card.

2 Stick the white and black strips of card to the front of the main card. Then start gluing the outfits in place. For the dress suit, start with the trousers and stick the jacket over the top. The dress from this template is all one piece. If you are designing your own outfit, work out the order of layers before sticking in place.

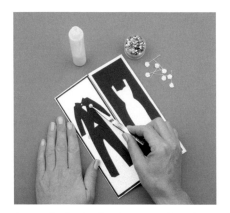

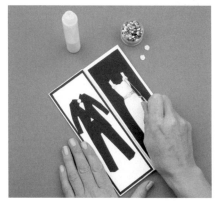

3 Now for the details. The groom's bow tie has a large crystal gem stuck down with the same PVA adhesive. Use tweezers to make positioning easier.

4 Then move to the bride. Here, she has a piece of narrow ribbon around her waist and small paper flowers stuck around the hem, on her waistband and at the shoulders.

Beautiful beads

The beauty of this design is its simplicity both in terms of adornment and the use of colour. White is a classic wedding colour and silver looks quite wonderful alongside it.

You will need

pearlescent white single-fold card (105 x 148mm)
paper punch (square) or craft knife and cutting board
beading wire (silver)
beads (assortment)
double-sided tape
scissors
angel hair (silver)
liquid pearl drops (silver)
fine black pen

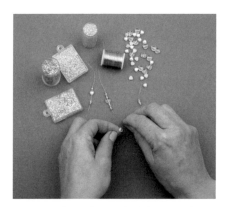

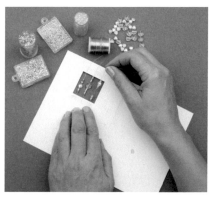

1 Prepare the main card by either stamping out the aperture or using a craft knife on a cutting board. This aperture measures 35mm square. Thread enough beads onto the beading wire so that you have three separate lengths that will fill the window of the card.

2 On the reverse side of the window, stick a strip of double-sided tape at the top and bottom of the aperture. Then fasten the beads onto the tape and trim off excess wire with scissors.

Useful tips

- Instead of making your own aperture, you can buy pre-cut cards, but you might not then be able to use the lovely wedding-type pearlescent card.
- When writing your message inside the card remember not to write too near the top or you will see it through the aperture.

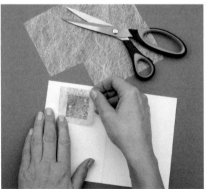

3 Cut a square of the angel hair that is slightly larger than the aperture. Stick another strip of double-sided tape down each side of the aperture and fasten the angel hair.

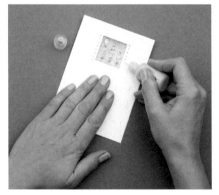

4 On the front of the card, use the liquid pearl drops to apply small dots to each side of the aperture. Add your message inside the card beneath the aperture.

Golden wedding

After 50 years of marriage, it has to be gold that the happy couple celebrates with. This design is clearly readily adaptable for whatever anniversary the recipients are celebrating: use a metallic grey for ten years (tin), pearlescent white for 20 (china) and the shiniest of silvers for 25 years.

You will need

gold single-fold card
(128 x 128mm)
cream pearlescent card
(118 x 118mm,
55 x 55mm)
paper trimmer or scissors
shape embosser
hole punch (small single)
gold thread
foam pads
PVA adhesive
tweezers
peel-offs (numbers,
border)

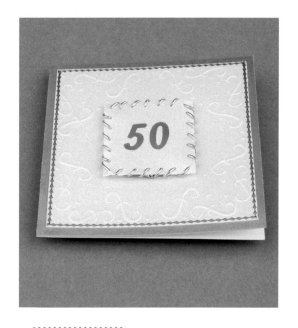

Useful tips

• If you don't have a hole punch, make holes in the card with a needle.

• The gold thread on this card came from a chocolate box! Keep all such spare bits of packaging – they come in useful in the end.

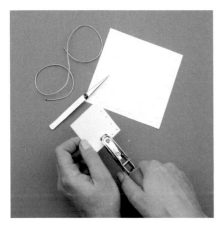

1 Dry emboss the corners of the larger piece of cream pearlescent card (see pages 46–7). Then use the hole punch to make holes around the edge of the smaller piece of cream pearlescent card.

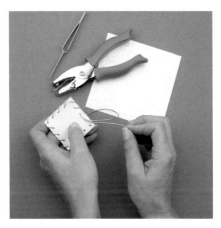

2 Pass the gold thread through all the holes around the edge, working from front to back each time.

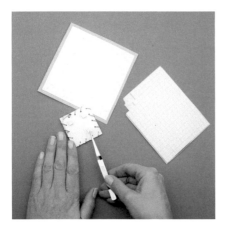

3 To give the card extra depth, stick the central square in place using a double layer of foam pads – two on each corner. Glue the completed design to the main card.

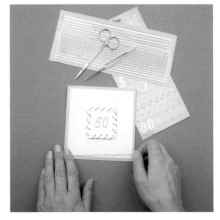

4 Stick the numbers in the centre of the card or hand write with a gold pen if you prefer. For the final piece of adornment, stick a peel-off border all the way around the edge.

A single rose

A single red rose says so much – and looks very charming on a card, too. Small pressed flowers, such as this, are available in packets so are a handy stand-by.

You will need

white single-fold card
 (128 x 178mm)
olive green pearlescent
 card (100 x 160mm)
silver card (56 x 35mm)
white card (55 x 75mm,
 52 x 30mm)
pink mulberry paper
white handmade paper
paper trimmer or
 scissors
pencil
hole punch
4 eyelets (olive green)
eyelet setter
cutting mat
steel ruler
paintbrush
corner paper punch
glue stick
PVA adhesive
dried flower
tweezers
braids (shades of pink)
rubber stamp (message
 of choice) and black
 ink pad or fine black
 pen

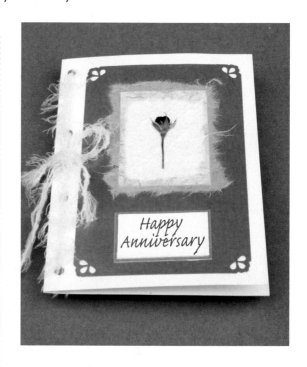

Useful tips

• You can buy corner punches with a variety of designs built into the one punch.

• A glue stick is the best adhesive to use for handmade mulberry and other textured papers. PVA adhesive is best for heavier-duty papers and cards.

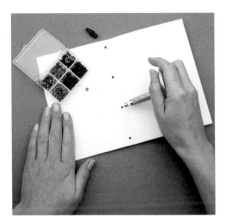

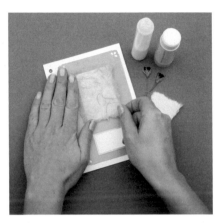

1 Using the pencil, mark on the front of the card where four eyelets are to be positioned, ensuring they are equally spaced. Use the technique shown on pages 56–7 for inserting the four eyelets.

2 Following the instructions on page 37, tear the pink and white papers to an appropriate size. Cut the decorative corners from the olive green pearlescent card. Start layering as shown opposite using the PVA adhesive for the card and the glue stick for the mulberry paper.

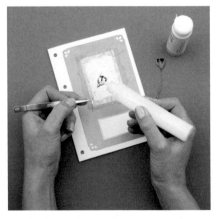

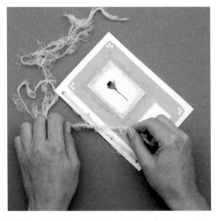

3 Stick the dried flower in the centre of the card using the PVA adhesive.

4 Thread the braids through the eyelets and tie in a bow to finish off attractively. Apply the message of your choice using the stamp and black ink pad or fine black pen.

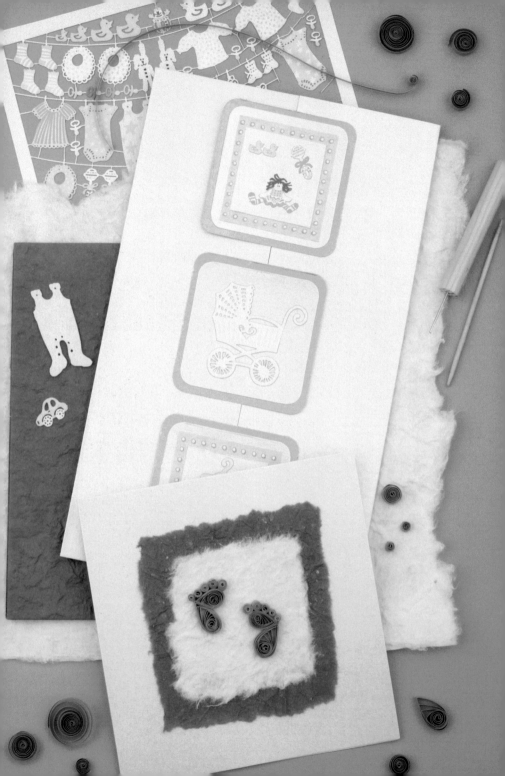

5 Cards for babies

Any of the cards in this section can be made in pink or blue – for now, we've suggested two of each – or, of course, you can make them in any other colour that takes your fancy: pale yellow or lilac, perhaps. There are many beautiful baby embellishments available in craft shops, ranging from tiny coloured safety pins and ribbons to baby stickers and peel-offs. So have fun choosing your favourites.

Pitter patter

Baby hand- and footprints are guaranteed to lighten the heart, which is probably why there are so many stencils and stamps that feature them. By using the dry embossing technique to make this card, texture is added to the design, delicately enhanced by a chalked finish.

You will need

pale blue pearlescent
single-fold card
(120 x 120mm)
dark blue pearlescent
card (80 x 85mm)
pale blue pearlescent
card (62 x 68mm)
white card (56 x 62mm)
paper trimmer or
scissors
light box
metal stencil (hands and
feet)
masking tape
embossing tool
chalk (pale blue)
applicator
PVA adhesive
hole punch
4 eyelets (pale blue)
eyelet setter
cutting mat

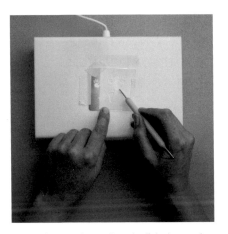

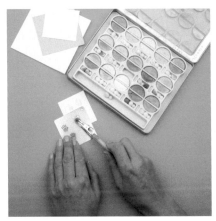

1 Put the metal stencil on the light box and fix in place with masking tape. Fasten the small piece of white card over the stencil with more masking tape and then use the embossing tool to press down on the stencilled area (see page 48).

2 Turn over the embossed card and put the metal stencil on the top to act as a mask. Use the chalk applicator tool to lightly dust pale blue (or pink) chalk onto the feet and hands.

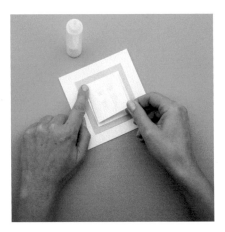

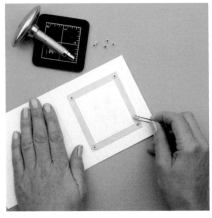

3 Stick all the layers of card to the main card, finishing off with the embossed and chalked hands and feet.

4 To finish, add an eyelet to each corner of the darker blue square (see pages 56-7).

Footprints

The choice of background paper for a card is every bit as important as the main focal point. With today's wide range of choice, both for patterned and handmade textured papers, take your time deciding what works best for what you have in mind.

You will need

pale pink pearlescent single-fold card (130 x 130mm)
background paper (110 x 110mm)
pale pink pearlescent card (90 x 90mm)
white card (84 x 84mm)
spare piece of white card
pale pink vellum (75 x 75mm)
paper trimmer or scissors
paper punch (feet)
glue stick
PVA adhesive

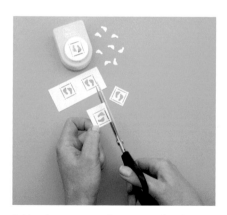

1 Use the paper punch to cut out four images from the space piece of white card. Cut them into four separate squares as near to the image as possible.

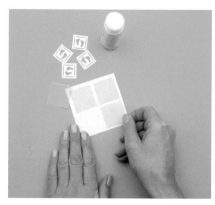

2 Tear the vellum into four squares (see page 38) and stick onto the pale pink pearlescent card with the glue stick.

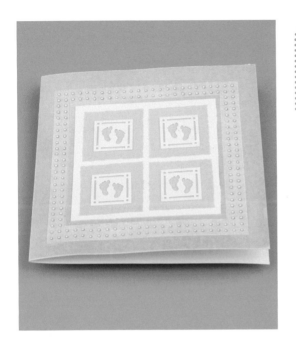

Useful tip

With some stamps you can use the negative image, as here. The feet that have been stamped from the centre of the square can be used in another design.

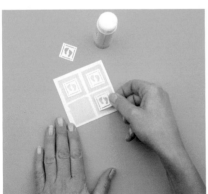

3 Stick the cut-out feet into the centre of each pink vellum square.

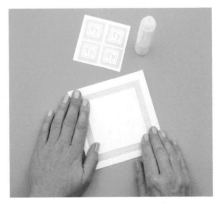

4 Piece together all the layers of the card, remembering to use PVA adhesive for the pearlescent card.

Twinkle toes

Once you've mastered the art of making different quilling shapes, you can start combining them to make whatever picture or pattern you desire. As the quills are made of paper they stick together very easily and you can choose to be as colourful or monothematic as you like.

You will need

pale blue pearlescent single-fold card (120 x 120mm)
handmade papers (blue, white)
quilling paper (blue)
scissors
quilling tool
cocktail stick
PVA adhesive
steel ruler
tweezers

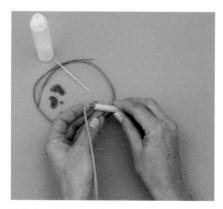

1 Follow the instructions on pages 64–5 to make quill shapes for each foot as follows: five small coils for each toe and two tear drops for the main part of the foot.

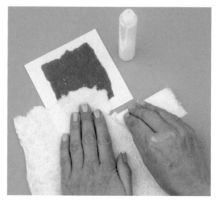

2 Following the instructions on page 38, tear the handmade papers to an appropriate size, ensuring the white is smaller than the blue.

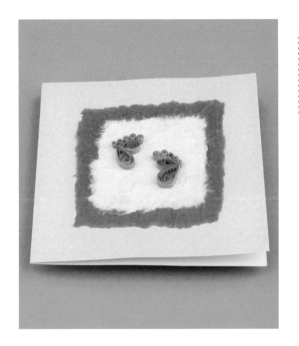

Useful tips

- When sticking down a combination of quilled shapes, it is best to start with the largest piece first.
- You can buy a quilling board, which is a template to help shape your quilled motifs. This is very useful if you need several motifs exactly the same size.

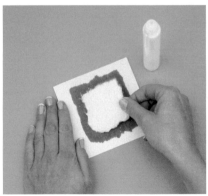

3 Use the PVA adhesive to stick the torn paper squares in layers to the front of the main card.

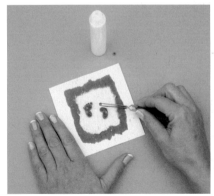

4 Still using the PVA adhesive and tweezers, stick the quilled shapes in the centre of the card, making two tiny feet with toes.

Shake, rattle and roll

Go to any craft shop or internet site and you will find sheets and sheets of pictorial embellishments. Where there were once just stickers, there are now sets of images in a multitude of themes. They can be expensive but as there are usually plenty of cutouts on each one, you can use them for lots of cards.

You will need

pale pink pearlescent card (255 x 210mm) folded into a gatefold card of 128 x 210mm
3 dark pink pearlescent card squares (60 x 60mm)
3 pale pink pearlescent card squares (52 x 52mm)
2 patterned background paper squares (45 x 45mm)
2 pale pink pearlescent card squares (35 x 35mm)
paper trimmer or scissors
paper punch
PVA adhesive
paper embellishments
tweezers

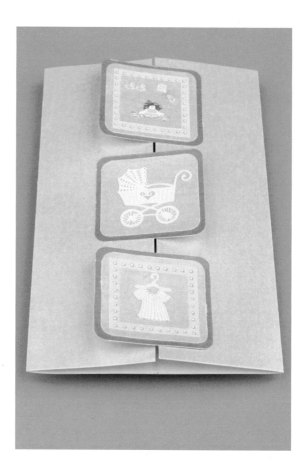

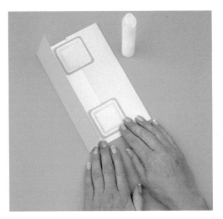

1 Prepare the pieces of card that will be layers on the front of the gatefold: there are four layers for the top and bottom attachments and just two in the centre (see the finished picture, opposite). Use the corner punch to round the edges of the bottom two layers.

2 Stick together the layered squares and attach the top and bottom squares to the edge of the right-hand side of the gatefold.

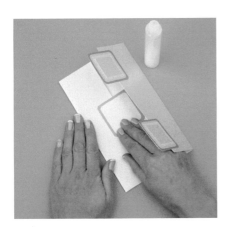

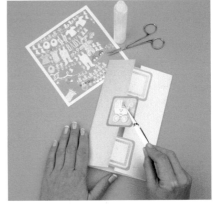

3 Stick the remaining layered square onto the centre of the edge of the left-hand side of the gatefold, ensuring its sides are neatly aligned with the top and bottom squares.

4 Decorate each layered square with whatever embellishment you like. Here there are various baby accoutrements taken from a sheet of paper embellishments.

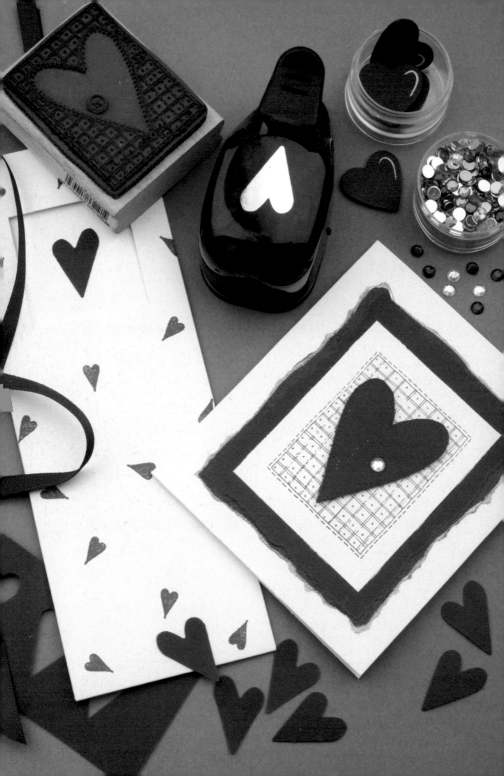

6 Cards for Valentines

It is easy to get inspiration for Valentine cards when you look around craft shops. There are so many rubber stamps and paper punches available with a heart theme. Also, hearts are very easy to draw freehand and when filled in with a gel pen give a truly professional looking finish to your card. Alternatively, there are sheets of heart stickers, peel-offs and background papers available with which to decorate your cards.

Ties that bind

Although making your own card blanks is not difficult, it can be useful to have a few ready-made ones to hand, especially if they are slightly more unusual, like this one.

You will need

ready-bought cream pocket card with insert (75 x 205mm) and square aperture
red card (scrap)
paper punch (heart) (optional)
PVA adhesive
small length of ribbon (red)
rubber stamp (small heart)
ink pad (red)

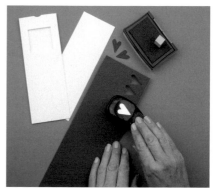

1 Punch (or cut) out as many hearts from the red card as you want to use. Although there is only one heart on the insert of this card, it could be decorated with many more (or you could be making more than one card!).

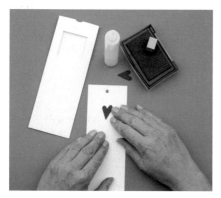

2 Remove the card's insert and stick one heart onto it, ensuring it will show through the pocket's aperture once slid back in.

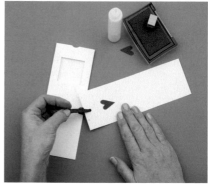

3 Attach the ribbon to the hole on the insert. Fold in half and thread the loose ends through the loop.

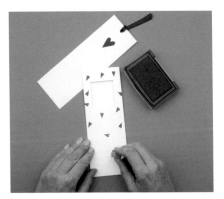

4 On the pocket, scatter stamped red hearts all over it – on both sides, if you wish.

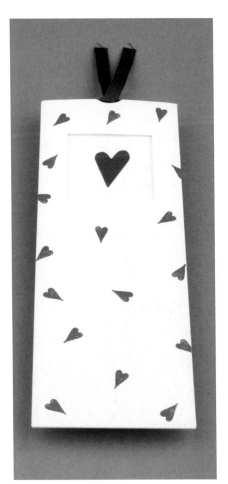

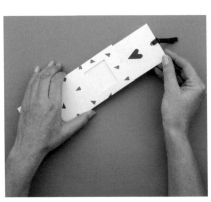

5 Slide the insert into the pocket and send to your beloved, writing your message on the insert below the heart.

All patched up

This love-ly card shows how a rubber stamp can be used to create a three-dimensional image by repeating a part of it to further the layered effect of the design. If you don't have a rubber stamp for the heart and background, draw and cut out a heart and use a fine black pen to add the patchwork details.

You will need

white single-fold card
 (105 x 123mm)
red card (90 x 105mm)
white card (63 x 79mm)
paper trimmer or scissors
rubber stamp (patchwork
 heart)
ink pad (black)
steel ruler
ink pad (silver) or silver
 marker pen
PVA adhesive
3–4 foam pads
tweezers
diamond gem
fine black pen

Useful tips

• Tweezers are a useful addition to the tool kit as they help with the positioning of fiddly items such as the jewel on this heart.
• For highlighting the edges of the torn paper, a silver marker pen works just as well as a silver ink pad.

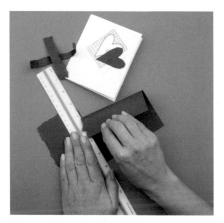

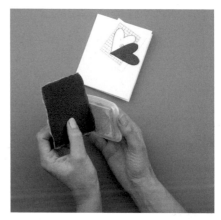

1 Use the patchwork heart to stamp black ink on the red card (see pages 40–1) and cut out. Use the same stamp to make the pattern on the background white card. Cut the red card to be just larger than the main card and use the steel ruler to create the torn edge effect (see page 38).

2 To soften the edges of the torn red card still further, rub the silver ink pad up and down across the torn areas.

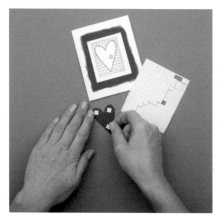

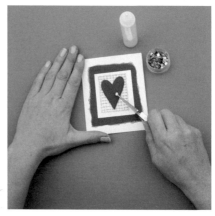

3 Piece together the layers, as shown above. To give the heart its three-dimensional effect, attach it with three or four foam pads.

4 Using the tweezers, stick the diamond gem to one side of the heart.

Heart to heart

Like the tiny feet on page 118 this design is based on using the 'negative' of a paper punch. Save all the hearts that are leftover – you're bound to find a use for them on another design.

You will need

white single-fold card (120 x 120mm)
red card (100 x 100mm)
white card (80 x 80mm, scrap)
paper trimmer or scissors
paper punches (corner, hearts)
glue stick
foam pads
fine black pen

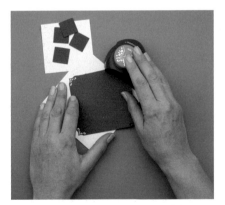

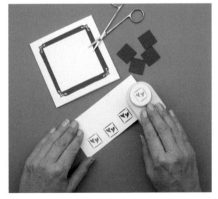

1 From the red card cut a square slightly smaller than the main white card: 100 x 100mm. Make decorative corners using the punch. Then cut out a square from the white card measuring 80 x 80mm. Stick the red square to the main white card and then stick the smaller white square on top.

2 Cut out four red card squares to the same size as the hearts motif. Then punch four heart motifs out of the scrap of white card.

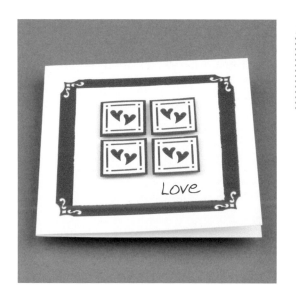

Useful tip

When there are small pieces of paper to stick together, as here, a glue stick can sometimes be easier to use than a tube of PVA adhesive.

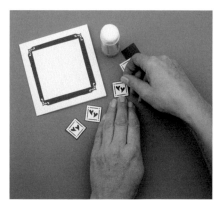

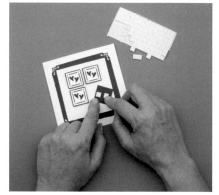

3 Stick the white cut-out motifs to the small red squares.

4 Stick the red squares to the main card using foam pads to give them a three-dimensional effect. Either centre the squares on the card as a whole or if you are adding the word 'love' (as pictured here), position them slightly above the centre line.

Love hearts

Just as card-making embellishments have multiplied over recent years, so have present-wrapping adornments. Keep all those pretty bits of ribbon from gifts you receive – you never know when you will have need of them for your cards. Storage boxes abound, too. Keep ribbons in one, pens in another ...

You will need

gold single-fold card
 (148 x 105mm)
gold card
 (scraps)
160mm length of
 40mm wide
 ribbon (black with
 red dots)
adhesive applicator
scissors
peel-offs (border
 and corner
 images)
tweezers
paper punch (heart)
foam pads
rubber stamp
 (message of your
 choice) and black
 ink pad or fine
 black pen

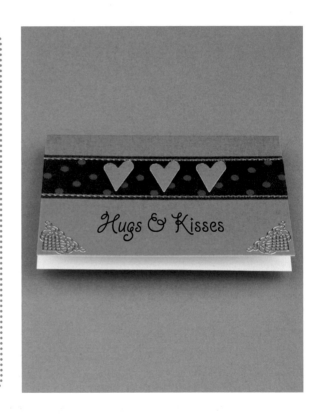

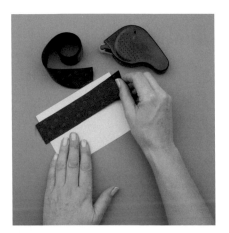

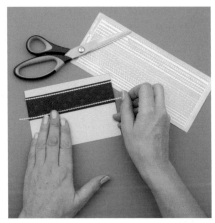

1 Stick the ribbon onto the main card using the adhesive applicator. Trim off excess ribbon with scissors.

2 Stick a peel-off border just inside the top and bottom edges of the ribbon.

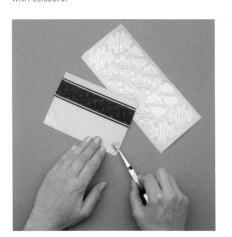

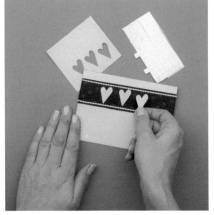

3 Using tweezers, stick a peel-off image onto each of the bottom corners.

4 Punch three gold hearts from the gold card and stick into position with the foam pads, using two or three on each heart to give them a three-dimensional effect. Apply the message of your choice using the stamp and black ink pad or fine black pen.

7 Invitations

Gatefold cards are an ideal shape for invitations with the announcement of a party on the outside and the details of the event behind the doors. It's great to involve children in making their own party invitations and the potato stamp invitation shown on page 144 is especially suitable for this sort of activity. Making your own wedding invitations has become very popular and there are some wonderful stickers and peel-offs available, which are especially useful if you're not happy with your handwriting.

Come to my party

As with all the other cards in this book, if you particularly like a design but it doesn't exactly fit what you have in mind, then adapt it. On this one, choose other suitable images, change the colour of the card and/or ribbon and increase or decrease the number of circles for the message accordingly.

You will need

pale blue card for envelope (280 x 210mm)
pale blue card for tag (93 x 175mm)
dark blue card (scraps)
envelope template (see opposite)
scissors
pencil
bone folder (optional)
PVA adhesive
hole punch
100mm x 3mm-wide dark blue ribbon
paper punch (small circle)
glue stick
black pen
party stickers or paper embellishments

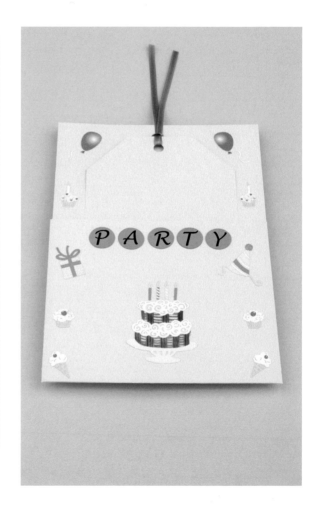

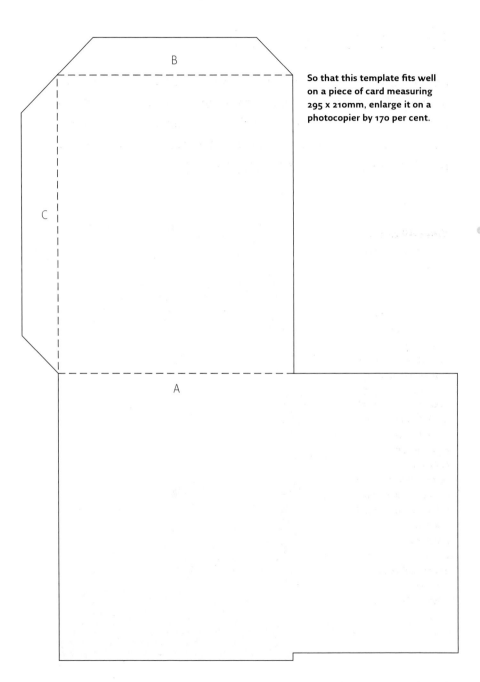

So that this template fits well on a piece of card measuring 295 x 210mm, enlarge it on a photocopier by 170 per cent.

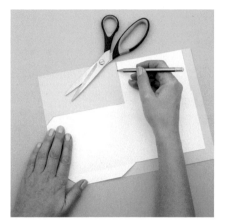

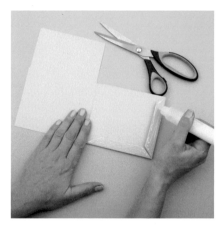

1 Photocopy the envelope template (enlarging as necessary), cut it out and draw around it on the card. Cut out with scissors.

2 Fold and make strong creases along line A and tabs B and C. Put PVA adhesive on the edge of the tabs and fold the card in half with the tabs on the inside so the back of the invitation looks very neat.

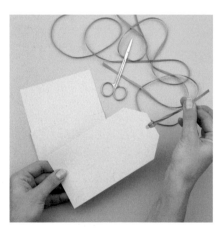

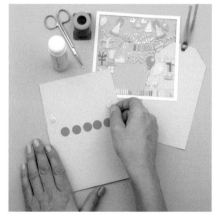

3 Cut off the top corners of the tag so it looks like a large luggage label. Use the hole punch to make a hole in the centre and feed through the ribbon.

4 Cut out five dark blue circles using the paper punch and stick to the envelope with the glue stick. Write the letters 'P', 'A', 'R', 'T' and 'Y' in each of the circles. Decorate the envelope with party stickers or paper embellishments and write the message on the tag before sliding into the envelope.

Spirelli wedding invite

To personalise this invitation, choose the card and ribbons to team with the wedding plans. For example, the ribbons might match the ribbon being used in the bridesmaids' headdresses.

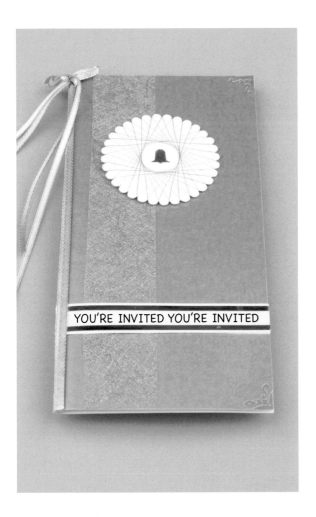

You will need

pearlescent single-
 fold card
 (100 x 210mm)
silver card
 (25 x 210mm)
white card
 (100 x 16mm)
paper trimmer or
 scissors
spirelli template
silver beading wire
corner paper punch
silver angel hair
 (35 x 210mm)
adhesive dispenser
PVA adhesive
silver adhesive strips
foam pads
small bell
 embellishment
fine ribbon (white and
 silver, lilac and
 silver)
rubber stamp
 (message of your
 choice) and black ink
 pad or fine black pen

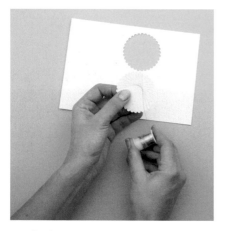

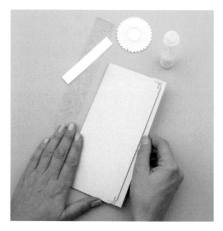

1 Following the instructions given on pages 66–7, wrap the silver beading wire around the spirelli template.

2 Use the corner punch to make decorative corners at the top and bottom of the main card and glue the strip of silver card behind.

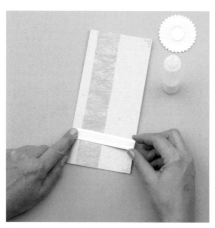

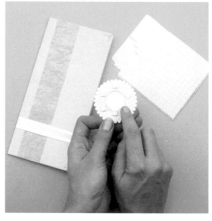

3 Stick the angel hair in place using the adhesive dispenser. On the top and bottom edges of the label, stick a strip of silver and then stick the label onto the main card.

4 Stick foam pads around the back of the spirelli circle. As it is heavier than your average piece of card you may need more than you might usually use.

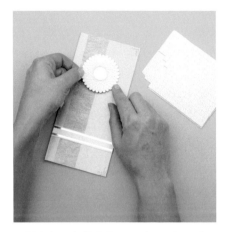 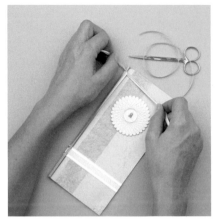

5 Stick the spirelli circle onto the surface of the main card ensuring it is centred to the width of the card. Stick the silver bell in the centre of the spirelli shape. This one is taken from a pack of wedding confetti.

6 Tie the ribbon around the folded edge of the card and finish with a neat bow. Apply the message of your choice using the stamp and black ink pad or fine black pen.

Useful tips

- It is best to cut items such as the angel hair and the label a little longer than you will require and then trim to fit once they are stuck down in place.
- You don't have to decorate the centre of the spirelli circle with a wedding bell – you can use whatever wedding motif you like, such as a peel-off wedding ring. If you are making this card for another occasion, then seek out any other suitable embellishment.

Scrapbook shapes

Scrapbooking has become a very popular craft hobby. Begun in America, this way of creating a journal or displaying favourite photographs has spread across the world. This card uses the idea of combining different papers to form a background or frame to the main image – in this case, an invitation to a party.

You will need

white single-fold card (128 x 178mm)
various background papers
paper trimmer or scissors
paper punch (flower)
glue stick
hole punch
8 eyelets (pale blue)
eyelet setter
cutting mat

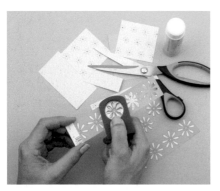

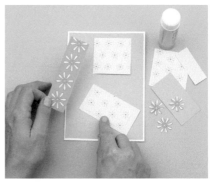

1 Cut out a background paper slightly smaller than the main card and also cut pieces of the patterned paper in smaller squares and rectangles. Use the paper punch to make some flowers (or any other shape that you have a punch for).

2 Stick the background paper to the main card and then arrange the smaller squares and rectangles until you are happy with the overall pattern.

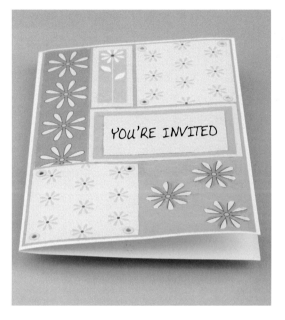

Useful tips

- If you are punching a pattern from paper, use the punch upside down so that you can accurately position the pattern.
- For the best effect, ensure that some of the patterns are cut in half, as though they are continuing onto another section.

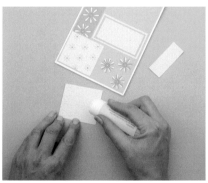

3 One by one stick the pieces in your chosen arrangement to the background paper ensuring the gaps between each one are as regular as possible.

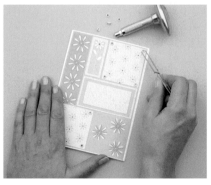

4 Use the eyelets as additional decoration, setting them as shown on pages 56–7. Here there is an eyelet in each corner of two of the squares. You might choose to use more or fewer or perhaps to use different colours.

Potato stamping

A gatefold card is an attractive and easy-to-make variation of the straightforward single-fold card. By attaching a label across the front on one side it makes opening up the card even more like opening a present. For a variation on this idea, see Shake, rattle and roll on page 122.

You will need

white card
 (295 x 210mm)
dark blue
 pearlescent card
 (95 x 76mm)
pale blue
 pearlescent card
 (75 x 58mm)
white card
 (68 x 50mm)
paper trimmer or
 scissors
3 new potatoes
sharp knife or craft
 knife
spoon
acrylic paints
 (6 pastel colours)
paintbrush
corner paper punch
PVA adhesive
rubber stamp
 (message of your
 choice) and black
 ink pad or fine
 black pen

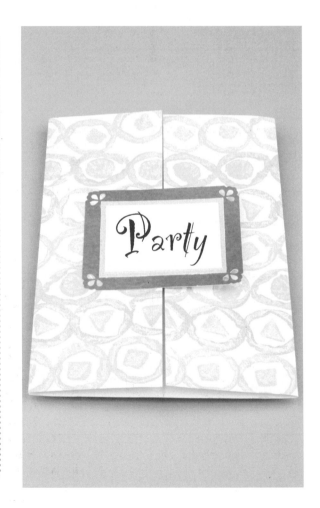

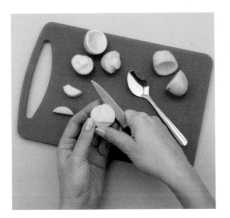

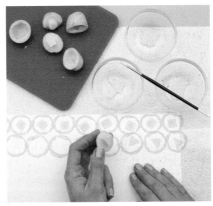

1 Cut the potatoes in half. On three of the halves, scoop out the centre. On the other three, cut back the edges, leaving a small circle, square and triangle in relief (for more information, see pages 42–3).

2 Using one potato circle, paint an acrylic colour around the edge and use this to stamp a row of circles along the length of the white card. Repeat with the square potato stamp. Repeat Step 2, working down the card with different combinations of acrylic paint. Leave to dry.

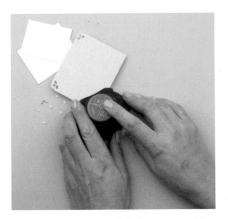

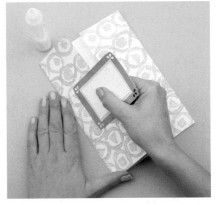

3 Make the label by cutting the corners of the dark blue card with the corner punch. Stick together the three layers. Fold the short edges of the printed card to the centre of the reverse side to make a gatefold.

4 Stick the label to one half of the gatefold, centring it to the height and the width. Then apply the message of your choice using the stamp and black ink pad or fine black pen.

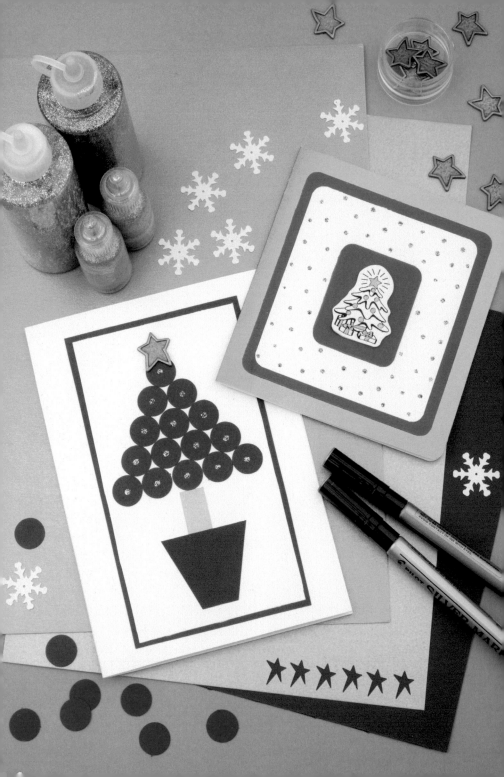

8 Christmas cards

It's great fun to make your own Christmas cards but do start them early as they always take longer than you think and it's good to have them finished by 1 December. Remember to make a few extra for those people you've forgotten to give to! Make your design fairly simple if you're making a large number of cards (the card on page 148, for example, is very quick to make) – and often the simple designs are the most successful anyway.

We three trees

Sometimes the simplest designs can be the most effective. The crystal lacquer pens used to fill in these trees have a beautiful shiny finish that will glisten by the Christmas lights.

You will need

silver single-fold card (100 x 118mm)
blue card (78 x 95mm)
white card (65 x 82mm)
paper trimmer or scissors
rubber stamp (Christmas trees)
ink pad (black)
silver marker pen
crystal lacquer pens (3 shades of green/blue)
PVA adhesive
glitter glue (silver)

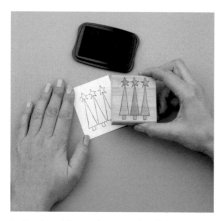

1 On the white card, stamp the Christmas trees image with black ink.

2 With the silver marker pen, fill in the star and trunks.

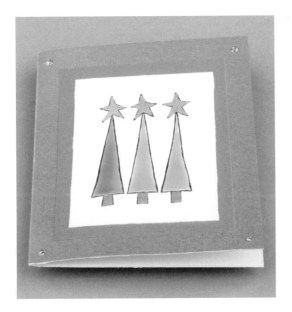

Useful tip

If any bubbles appear in the crystal lacquer, use a needle or pin to burst them.

3 Use the crystal lacquer pens to fill in the tree foliage – one colour for each tree. Put the card to one side until the crystal lacquer dries (about 30 minutes).

4 Glue together the background layers and stick on the main card. When the trees have dried, stick the white card on the top. Finish off by adding a dot of sparkly glitter glue in each corner of the card.

Christmas tree

At this festive time, no home would be complete without a Christmas tree and this very simple design reflects the trend for lots of white lights on the tree. To add more decoration, look for suitably patterned paper for the pot or add embellishments to it once you have stuck everything else in place.

You will need

white single-fold card
(128 x 178mm)
dark green card
(90 x 158mm)
white card (84 x 152mm)
red, silver and green
card (scraps)
paper trimmer or
scissors
paper punch (circle)
PVA adhesive
silver metal star
metal glue
glitter glue (silver)

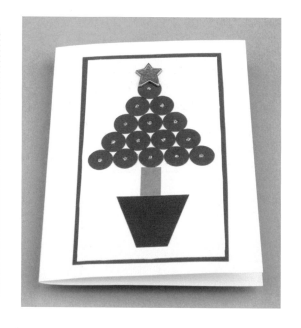

Useful tip

Small metal shapes are a lovely addition to a card but as they are heavy they must be stuck down with metal glue or they will fall off all too easily.

1 Cut out the red pot, silver trunk and, using the paper punch, 15 circles from the green card. Stick the green and white rectangles to the main card.

2 On the layered background, stick down the red pot and silver trunk. Build up the Christmas tree by sticking the circles on in rows, as shown opposite.

3 Using metal glue, stick the silver metal star at the top of the tree.

4 Add the Christmas tree lights by dabbing a little glitter glue into the centre of each of the green circles.

Dancing snowflake

If you are going to make lots of these cards for Christmas, it would be a good idea to buy a circular paper punch to make the aperture as this certainly helps to speed up the mass production.

You will need

pearlescent blue card (220 x 220mm)
tree template (see below)
scissors
rubber stamp (small snowflake)
ink pad (silver)
2 snowflake embellishments
PVA adhesive
2 crystal gems (blue)
hole punch
1 silver eyelet
eyelet setter
cutting mat
white thread
needle

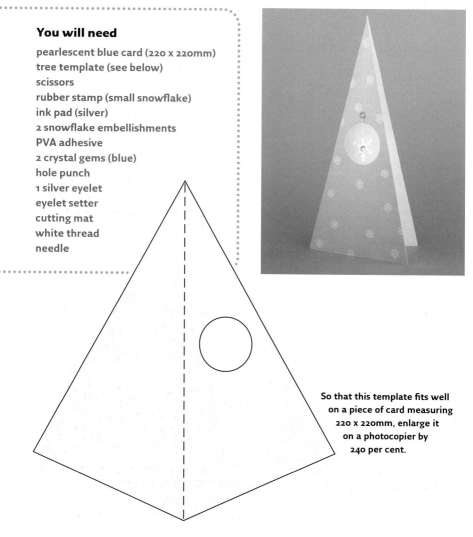

So that this template fits well on a piece of card measuring 220 x 220mm, enlarge it on a photocopier by 240 per cent.

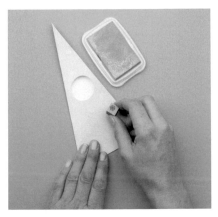

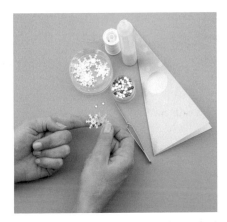

1 Enlarge the template, cut it out and draw around it on the back of the pearlescent blue card. Cut out, including the circle in the centre. Fold in half and on the front of the card, stamp silver snowflakes in a random fashion all over it.

2 As the reverse side of the snowflake embellishments are white, stick together two of them so that when it swings around on the finished card the snowflake continues to glisten. To finish the snowflake, stick a gem in the centre on each side.

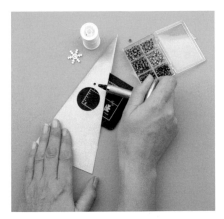

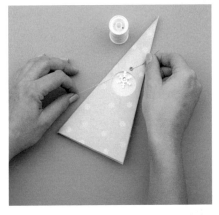

3 Using the eyelet kit, insert an eyelet just above the aperture (see pages 56–7).

4 Thread a length of white cotton through the needle and push through the snowflake. Then pass the needle up through the eyelet and tie a knot to finish. Trim off any loose ends.

Mini-tree

Shrink plastic is a comparatively new craft material and not only is it fun to work with, but it adds an extra dimensional quality to the finished look of any card.

You will need

gold single-fold card (120 x 130mm)
green card (100 x 110mm, 45 x 55mm)
white card (90 x 100mm)
paper trimmer or scissors
shrink plastic
rubber stamp (Christmas tree)
ink pad (black)
gold marker pen
heat tool
PVA adhesive
glitter glue (gold)

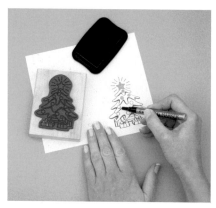

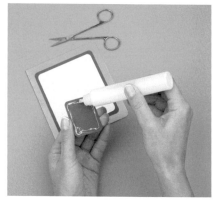

1 Stamp your image in black onto the shrink plastic and colour in parts of the design with the gold marker pen. Follow the instructions on pages 70–1 for heat-shrinking the plastic.

2 Round the corners of each of the layer squares with scissors (or a corner stamp, if you have one). Using the PVA adhesive, stick the layers of card to the centre front of the main card: the order is green, white, green.

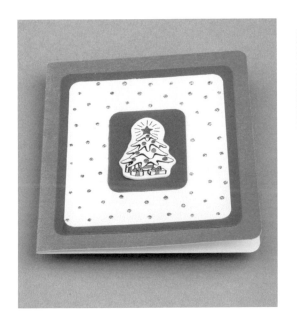

Useful tips

- When stamping onto the shrink plastic, do it on the rough rather than the shiny side.
- To ensure the shrinked image is flat when it has finished decreasing in size and before it cools, cover it with a heavy book and press.

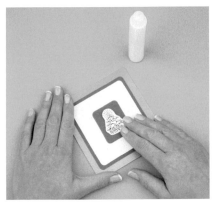

3 Stick the shrink plastic icon to the centre of the card. PVA adhesive is the best glue to use.

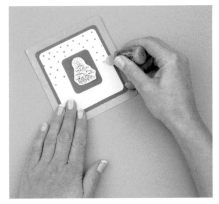

4 Add decorative gold glitter glue dots all around the edge of the card.

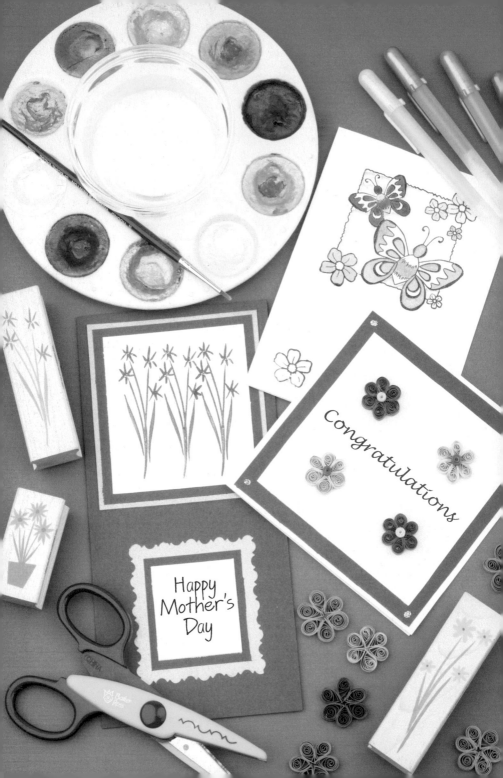

9 Cards for other occasions

This section includes some designs that could be adapted to any occasion by simply changing the message on them, such as the three cards shown on the left. Giving someone a card you have made yourself and designed with that person in mind, featuring their hobby or interests, can be so rewarding.

Butterflies

Any stamp that you have can be used in the same way as on this design. Just ensure you choose carefully so that there is a background that can be cut out. When you write your message, make sure you don't write behind the area that is cut away or you will spoil the finished effect of your carefully created card.

You will need

white single-fold
 card (105 x
 148mm)
rubber stamp
 (butterflies)
ink pad (black)
clear embossing
 powder
heat tool
small detail scissors
 or cutting mat and
 craft knife
watercolour paints
paintbrush
foam pads
rubber stamp
 (message of your
 choice) or fine
 black pen

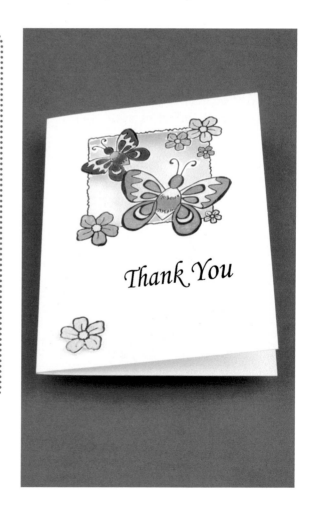

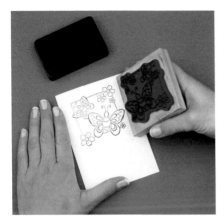

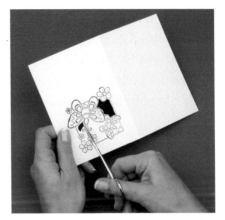

1 Use the rubber stamp and black ink pad to imprint your image on the front of the card. Use a part of the image for a small added detail. Follow the instructions on pages 44–5 for embossing the picture.

2 Using the small scissors (or cutting mat and craft knife), carefully cut out the background card around the image.

3 Paint the remaining image using watercolour paints. As the picture is embossed, the different areas are separated but nevertheless it is worth allowing each colour to dry before painting on the next.

4 For the final piece of decoration, cut out the image detail and stick to the card with a foam pad. Apply the message of your choice using the stamp and black ink pad or fine black pen.

Beautiful bouquet

The best type of background paper to use for a design like this features small images that are not too fiddly to cut out. You could always cut simple shapes from coloured card instead.

You will need

green single-fold card (110 x 138mm)
patterned background paper (100 x 138mm plus matching
 details cut from spare background paper)
green card (75 x 25mm)
paper cutter or scissors
fine cutting scissors
PVA adhesive
tweezers
foam pads
bone folder
100mm piece of narrow ribbon
small buckle embellishment

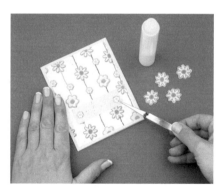

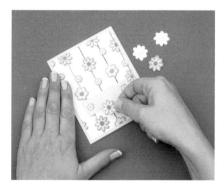

1 Stick the patterned background paper to the main card and then stick the message strip on top. Decorate with two details taken from the background paper.

2 To give the card a three-dimensional finish, stick a foam pad on the back of each of the cut-out details. Stick two of the details on top of each other over the matching image on the main background paper.

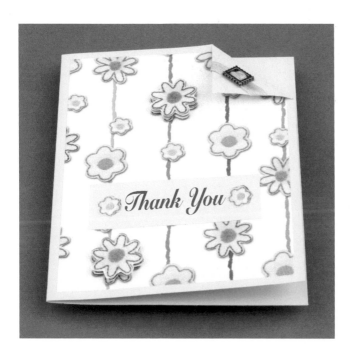

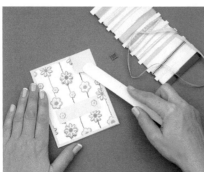

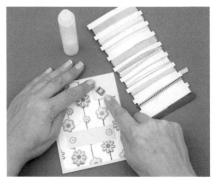

3 Fold over the top right corner and use the blunt end of the bone folder to make sure you have a strong crease.

4 Cut the piece of ribbon and thread the buckle onto the centre. Wrap the ribbon around the folded-over corner and stick the ends to the underside with PVA adhesive.

Mother's day posy

One stamp plus several repeats equals a lovely bouquet to give to your mother. For a mixed bunch of flowers clean the stamp between each use and use different coloured pens each time.

You will need

purple single-fold card (100 x 210mm)
gold card (90 x 96mm, 70 x 75mm)
purple card (84 x 90mm, 50 x 55mm)
white card (75 x 80mm, 43 x 41mm)
paper trimmer or scissors
rubber stamp (flower)
double-ended craft pens (green, purple, yellow)
decorative-edged scissors
PVA adhesive
rubber stamp (message of your choice) and black ink pad or
 fine black pen

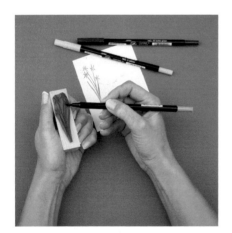

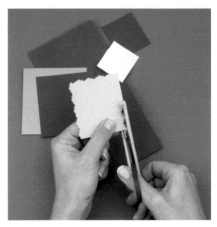

1 Use the craft pens to add colour to the rubber stamp (here we've used green for the leaves and purple for the flowers) and apply to the card. Repeat three times.

2 Cut down the layers of card ready for sticking to the main card and trim the smaller gold square with the decorative-edged scissors (see page 36).

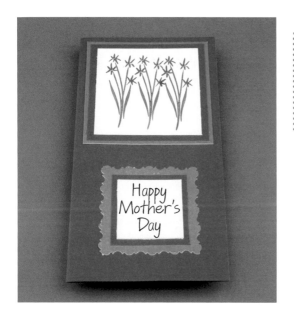

Useful tips

• You will need to apply the colour for each time you stamp. As the colour can dry quickly on the stamp, breathe on it prior to stamping to moisten it.

• Apply the stamp to a larger piece of card than you will ultimately need. It is then easier to cut down to size.

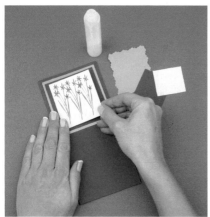

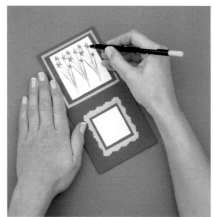

3 Stick the larger gold and purple squares to the top of the main card and then add the decorated flower square. Stick the message squares to the bottom of the card.

4 For a finishing touch, add yellow centres to the flowers with one of your craft pens. Apply the message of your choice using the stamp and black ink pad or fine black pen.

Father's day

This card combines the ideas used for Scrapbook shapes on page 142 and the simple monochromatic theme used for Spots on page 88. Layering different papers always creates an attractive visual contrast, and tearing paper for the background takes this even further, resulting in a truly eye-catching design.

You will need

white single-fold
 card (128 x
 178mm)
black card
 (58 x 38mm)
white card
 (54 x 34mm)
background papers
 (various)
paper trimmer or
 scissors
PVA adhesive
rubber stamp
 (message of your
 choice) and black
 ink pad or fine
 black pen

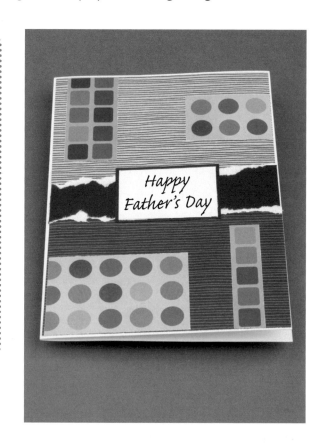

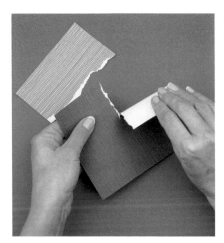

1 Following the techniques described on pages 37–8, tear two of the papers to give an attractive edge.

2 Cut the background papers to an assortment of sizes and shapes and glue the black card to the centre of the main card front.

3 Arrange the background paper shapes until you are happy with the way they look. Bear in mind that you will need to leave a space for the message label.

4 Stick the label in the centre and then apply the message of your choice using the stamp and black ink pad or fine black pen.

Easter egg

When using a rubber stamp, you don't have to use the whole image each time. Here just one of the eggs has been coloured in. The technique would have worked well to create a whole series of slightly different Easter cards.

You will need

white single-fold card
 (104 x 198mm)
white card (scrap)
green card (100 x 194mm,
 50 x 60mm, 80 x 33mm)
yellow card (55 x 65mm,
 46 x 54mm, 84 x 40mm,
 75 x 28mm)
rubber stamp (Easter eggs
 and message of your
 choice)
ink pad (black)
clear embossing powder
heat gun
jelly-roll glazed pens
paper trimmer or scissors
fine black pen
metal ruler
PVA adhesive
foam pads
4 flower brads (yellow)
hole punch

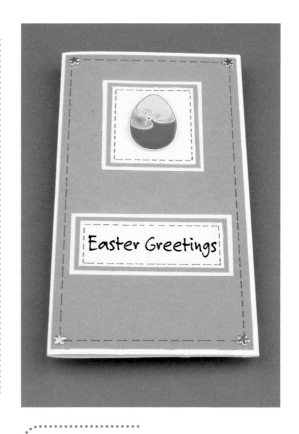

Useful tip
When using jelly-roll glazed pens, let each colour dry before filling in the next.

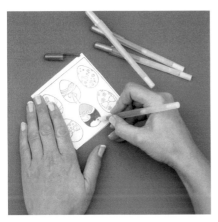

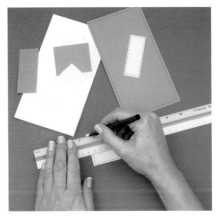

1 Stamp the image onto a piece of white card and then follow the instructions on pages 44–5 for heat embossing the picture. Use the jelly-roll glazed pens to colour one of the eggs and leave to dry (about 10 minutes).

2 Cut out the layered and label cards and use the fine black pen against the metal ruler to draw in the 'stitches' around the edges of the main green background and top yellow pieces of card.

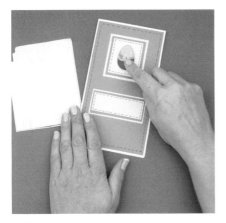

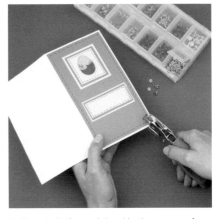

3 Stick the green background to the main card and then stick the layers for the image and message to the green card. Cut out the decorated egg and stick to its frame using some foam pads.

4 Cut a hole for each brad in the corner of the card and then insert the brads (see pages 58–9). Apply the message of your choice using the stamp and black ink pad or fine black pen.

Cheers!

With so many interesting templates available you can combine elements of them to create unique card designs. With the simple outlines used on this card, you can draw your own shapes or make your own stencil (see pages 48–9).

You will need
white single-fold card (116 x 210mm)
metallic silver card (60 x 135mm)
silver card (54 x 127mm)
white card (scrap)
paper trimmer or scissors
stencil (champagne bottle and glasses)
fine cutting scissors or a craft knife and cutting mat
chalk (grey)
applicator
PVA adhesive
10 diamond gems

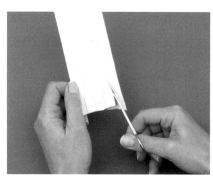

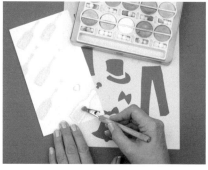

1 Draw two champagne glasses onto white card through the template and cut out with fine scissors or a craft knife and cutting mat. If you don't have a suitable stencil, make your own following the steps on pages 48–9.

2 Use the chalk and applicator through the stencil to make rows of champagne bottles. The stencil has been used at an angle here but you could choose to chalk vertical or horizontal bottles. Use two colours for a shaded effect.

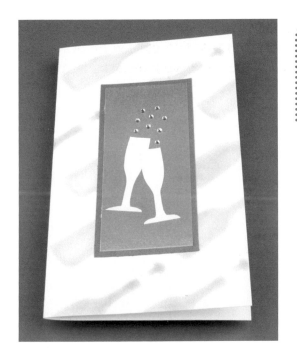

Useful tip

To stick on gems, put dots of glue on the card and stick the gems on the glue, rather than putting the glue on the gems and then trying to position them.

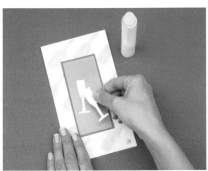

3 Stick the metallic silver and the silver card strips in the centre of the main card and then stick the two champagne glasses towards the bottom of the panel.

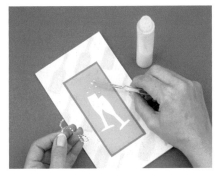

4 For added bubbles and sparkle, stick diamond gems above the glasses using PVA adhesive.

Get well soon

Teabag papers are available from craft shops and mail-order specialists (see page 188). The folding techniques are comparatively straightforward (see also pages 62–3) and you can create your own squares either by hand or on a computer. Whatever teabag papers you use, you can use this folding technique and card decoration idea.

You will need

pearlescent cream single-fold card (148 x 210mm)
rust card (110 x 110mm, 96 x 44mm)
pearlescent cream card (103 x 103mm, 88 x 36mm)
teabag papers (bought or homemade)
paper trimmer (optional)
scissors
PVA adhesive
double-sided tape (optional)
1 stud (gold)
tweezers
braids (orange, brown)
rubber stamp (message of your choice) and black ink pad or fine black pen

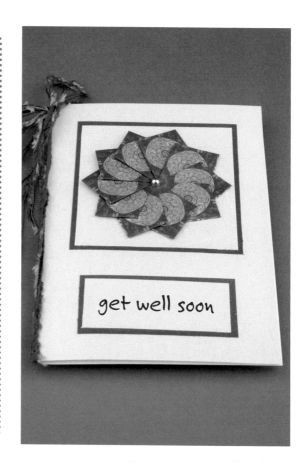

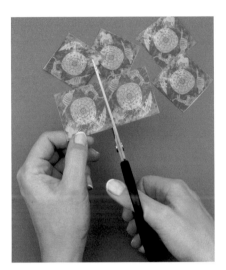

1 Cut ten squares from your chosen teabag paper. With each square, follow Steps 2 to 6.

2 Fold in half, wrong sides together, and open up. Fold in half the other way, wrong sides together, and open up.

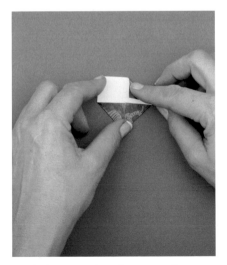

3 Fold the corners into the centre point.

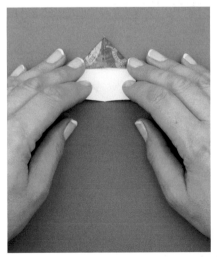

4 Open out two of the corners.

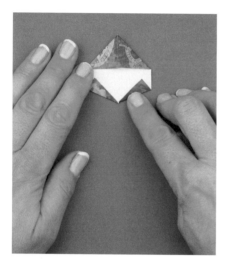

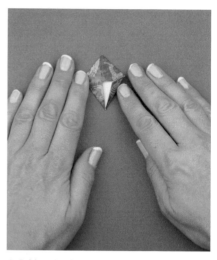

5 Fold one opened corner halfway towards the centre point. Repeat with the other opened-out corner.

6 Fold each of these edges once more, bringing the corners to the centre line. You are left with a kite-shaped piece of paper.

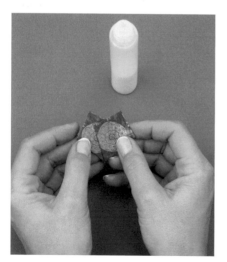

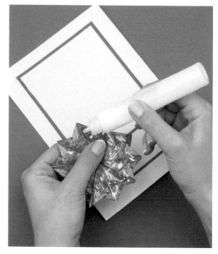

7 Using PVA adhesive or short strips of double-sided tape, stick together all the folded teabags so that they overlap to create a rosette. The edge of each folded teabag aligns with the central fold.

8 Stick the layered mount and label cards to the main card and then stick the teabag rosette to the centre of the top layered cards.

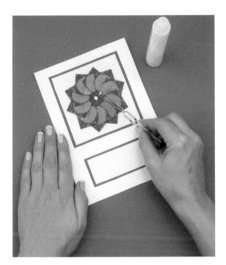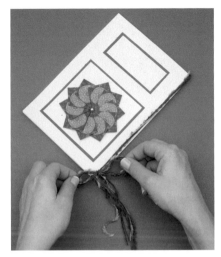

9 With the tweezers, stick the gold stud in the centre of the rosette.

10 To finish, tie a selection of contrasting coloured braids around the folded side of the card. Apply the message of your choice using the stamp and black ink pad or fine black pen.

Useful tips

• You needn't feel that you have to use teabag papers for making this card. Simply use your own paper or coloured design and fold as described in the steps.

• Using glue to stick together these small pieces of paper can be a messy business. So, to make life a little more straightforward, try using glue dots instead.

Get well soon

A scattering of lightly chalked flower stamps over a paler chalked background results in a calm and pretty card that would bring cheer to anyone not feeling too well. The same design would also make a really lovely birthday card as well.

You will need

white single-fold card (120 x 120mm)
chalks (blue)
cotton wool
rubber stamp (flower)
watermark ink pad
chalk applicator
glitter glue (silver)
rubber stamp (message of your choice) and black ink pad
 or fine black pen

1 Use a piece of cotton wool to lightly apply a background of chalk on the main card.

2 With the stamp, apply the image using the watermark ink pad.

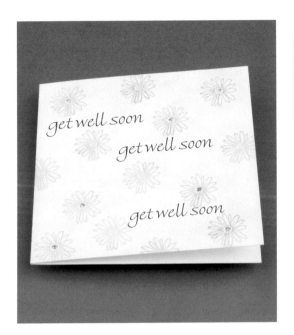

Useful tip

When using chalk to colour a background or larger area, it is best to use a piece of cotton wool rather than an applicator as this gives a softer finished effect.

3 Apply chalk with the applicator over the stamped images.

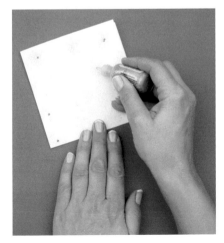

4 Add dabs of glitter to the centre of each flower and then add your message.

Thinking of you

Vellum papers have a slightly waxy finish and are available in plain and a wide variety of patterned finishes. They are also slightly transparent so if it's going to show, ordinary glue is best avoided. There is a special vellum glue available or use other fixtures, like the eyelets on this card.

You will need

white single-fold card
 (105 x 196mm)
blue card (65 x 194mm)
white card (60 x 45mm)
patterned vellum
 (55 x 194mm, 115 x 90mm)
paper trimmer or scissors
PVA adhesive
hole punch
6 eyelets (turquoise)
eyelet setter
cutting mat
foam pads

So that this template fits well on a piece of vellum measuring 115 x 90mm, enlarge it on a photocopier by 175 per cent.

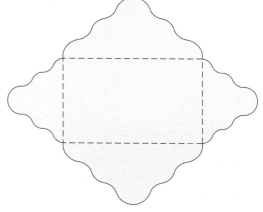

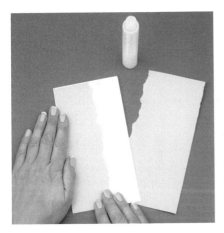

1 Tear the blue card and stick onto the front of the main card (see page 38).

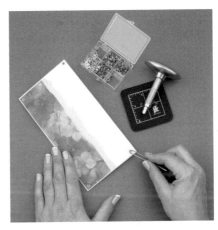

2 Attach the vellum strip over the blue card using eyelets in each corner (see pages 56–7). To balance the design, add two further eyelets on the outside edge.

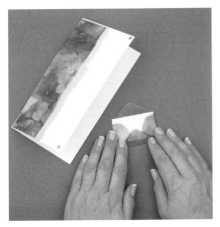

3 To make the vellum envelope, trace the template outline on to the vellum and cut out. Then position the label in the centre of the rectangle and fold over the edges.

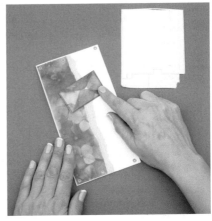

4 Stick the envelope to the front of the card with foam pads. Write your message on the card in the little envelope and send.

Congratulations!

Teardrop quills are just crying out to be combined to make beautiful flowers. Once you get going with making the quills, you will soon be producing them very quickly. They store well, too, so if you find you have some spare time, fill it with this calm paper-scrolling activity ready for when you next want to make a card.

You will need

white single-fold card
 (120 x 120mm)
purple card (115 x 115mm)
white card (98 x 98mm)
quilling papers (dark
 purple, light purple,
 mauve)
quilling tool
PVA adhesive
chalk (mauve)
applicator
template (squares)
paper trimmer or scissors
glitter glue (silver)

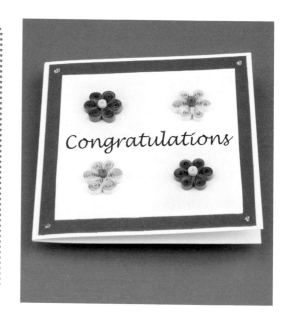

Useful tips

• When making the flowers, stick together the petals first and then add the centre on top.

• When making the flower petals it is important that the teardrops are all the same size. Keep those that come out too large or too small for use on another card – nothing need ever go to waste! Alternatively, invest in a quilling board (see page 121).

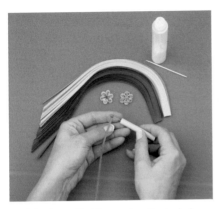

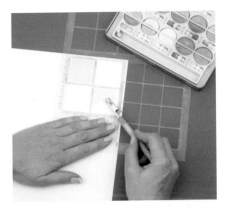

1 Make the quilled flowers (see the technique on pages 64–5). For each flower you will need to make one small coil for the centre and six teardrops for the petals. On this card there are two different colours of flower. Stick together the individual quills with PVA adhesive to make four flowers.

2 Before you cut the white card to size, apply mauve chalk to it through the template using the applicator. You don't have to have a template for this – cut or punch a square from a spare piece of card.

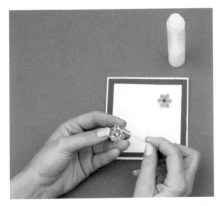

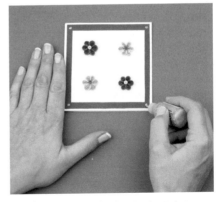

3 After chalking, trim the card to size and stick to the centre of the main card. Then glue the quilled flowers to the centre of each circle. A cocktail stick can be useful for applying the PVA adhesive to the back of the flowers.

4 Add small dabs of glitter glue in each corner for a lovely shiny finish.

You are a star

This card may look like the most complicated one in the book, but in effect it is just two cards joined to make a single, splendidly dramatic one. The clever positioning of a strip of gold card behind the punched corners on the front adds to the overall professional finish.

You will need

white/gold single-fold
 card (148 x 210mm)
white card (295 x 210mm)
white/gold card
 (30 x 210mm)
gold card (115 x 180mm)
white card (105 x 170mm)
paper trimmer (optional)
corner punch
star template (see page
 182)
pencil
scissors
bone folder
rubber stamp (stars)
ink pad (gold)
PVA adhesive
peel-off gold stars
tweezers
gold star stickers
metal ruler
gold pen
cotton thread and needle
Sellotape
corrugated gold star
glitter glue (gold)
peel-off letters

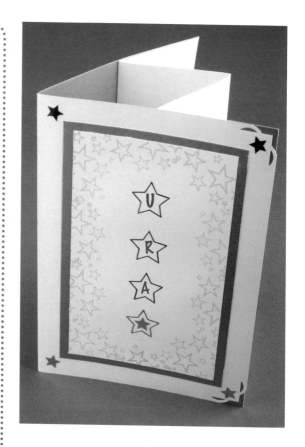

To make the card blanks

1 Fold the white/gold card in half with the white on the outside (this will be the outside of the card). Use the corner punch to make decorative corners on the front top and bottom and set to one side.

2 Fold the plain white card in half (this will be the inside of the card) and use the star template to draw the half star on the folded side of the card.

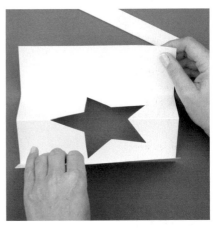

3 Cut out the star. If there are pencil marks still showing, don't worry as they will ultimately be covered with glitter.

4 Fold each side of the card back on itself so that you end up with a concertina fold. Use the bone folder to strengthen the folds. Set to one side.

So that this template fits well on a piece of card measuring 295 x 210mm, reduce it on a photocopier to 90 per cent.

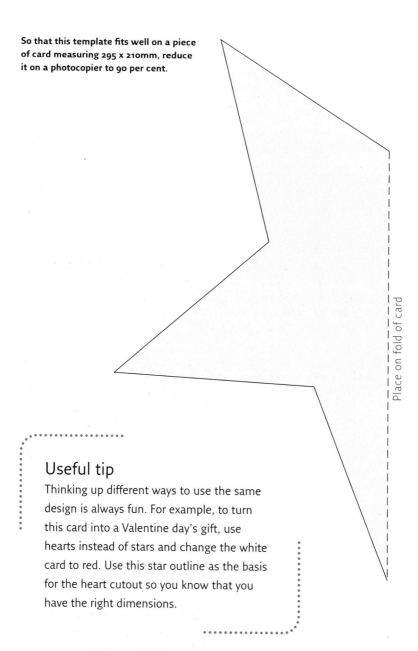

Place on fold of card

Useful tip

Thinking up different ways to use the same design is always fun. For example, to turn this card into a Valentine day's gift, use hearts instead of stars and change the white card to red. Use this star outline as the basis for the heart cutout so you know that you have the right dimensions.

To make the outside

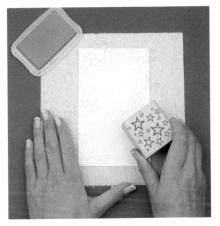

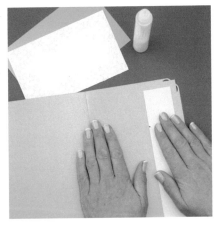

5 On the white card panel, use the rubber stamp and gold ink to make a pattern of stars all around the edge. Do this on some scrap paper and ensure you have incomplete stars on the side of the card.

6 Take the gold strip and stick behind the corner-punched front of the card. Ensure the gold side is facing out so that you can see it through the trimmed corners.

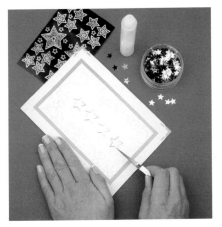

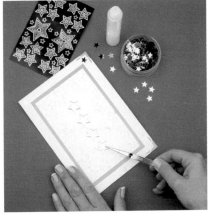

7 On the outside front, stick on the layers of card – gold first, followed by the stamped white panel. Stick four peel-off stars down the centre front of the panel.

8 For the finishing touch, put a gold star sticker in each corner and, if you are going to add the suggested message, add one to the centre of the bottom peel-off star. Alternatively, add a star to the centre of each peel-off.

The finishing touches

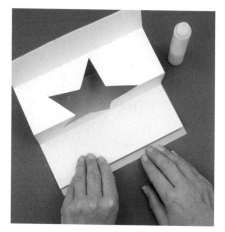

9 Stick the inside layer to the inside of the outer card ensuring the star fold is facing outwards.

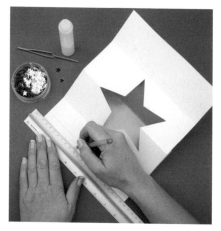

10 On the left-hand side of the card, draw two lines against the metal ruler using the gold pen. Make one line slightly longer than the other and add a gold star sticker at the end of each.

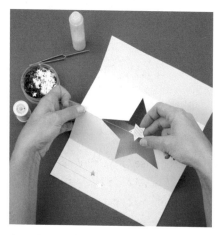

11 Using a needle, thread white thread to one point of the corrugated star and use a small strip of Sellotape to stick the other end of the thread behind the fold at the top of the star aperture.

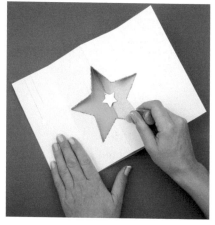

12 Add a narrow bead of gold glitter glue all around the edge of the star aperture. On the front of the card, add peel-off letters (as shown on page 180), if you are using them.

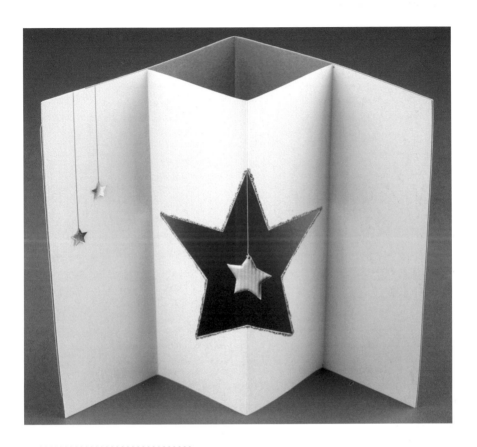

Useful tips

● The star pattern that is stamped on the front panel (see page 180) need not be as complicated as this one. You could alternatively use a single star stamp, if you have one, make a stencil from acetate (see pages 48–9) or use starry peel-offs.

● The letter 'U', 'R' and 'A' are on the front of the card so that it reads 'You are a star'. Alternatively, you could add a shiny gold star in the centre of each one or decorate them with any craft pen you have.

want to know more?

general suppliers

L. Cornelissen & Son Ltd
105 Great Russell Street
London WC1B 3RY
Tel: 020 7636 1045
www.cornelissen.com
(artists' materials)

Craft Creations
Ingersoll House
Delamare Road
Cheshunt
Hertfordshire EN8 9ND
Tel: 01992 781900
www.craftcreations.com
(wide range of craft supplies)

Cranberry Card Company
Unit 4
Greenway Workshops
Bedwas House Industrial Estate
Bedwas
Caerphilly CF83 8DW
Tel: 01443 819319
www.cranberrycards.co.uk
(card blanks, papers, templates,
stamps)

English Stamp Company
Worth Matravers
Dorset BH19 3JP
Tel: 01929 439117
www.englishstamp.com
(rubber stamps, ink pads,
handmade paper)

Hobbycraft
Craft suppliers with stores all over
the UK and Europe
For your nearest store,
tel: 0800 027 2387 or go to
www.hobycraft.co.uk
(general craft supplier)

Lakeland Ltd
Alexandra Buildings
Windermere
Cumbria LA23 1BQ
Tel: 015394 88100
www.lakelandlimited.com
(general craft supplier)

Paperchase
213 Tottenham Court Road
London W1T 7PS
For your nearest store,
tel: 020 7467 6200 or go to
www.paperchase.co.uk
(handmade papers, card, paper
punches)

want to know more?

other websites for general suppliers

www.artymiss.co.uk
www.cardmakingcrafts.co.uk
www.charmedcardsandcrafts.co.uk
www.clickoncrafts.co.uk
www.craftee.co.uk
www.craftsite.co.uk
www.eco-craft.co.uk
www.fidgetyfingers.co.uk
www.joannasheen.com
www.kookykards.co.uk
www.lawrence.co.uk (artists' materials)
www.mgrcrafts.co.uk
www.panduro.co.uk (hobby supplier with card making materials)
www.paperworkscardcraft.co.uk
www.stamps.co.uk

card making websites

www.cardinspirations.co.uk
www.cardmakingandpapercraft.com
www.craftcreations.co.uk
www.craftsitedirectory.com

specialist suppliers and websites

Many of these sites have galleries and ideas for card designs as well as supplying the necessary specialist materials.

Cross stitch
www.cross-stitch.com
www.johnsoncrafts.co.uk
www.sewandso.co.uk
www.stitchncards.com

Iris folding
www.cardinspirations.co.uk/demo/demo21.htm
CJ Crafts, tel: 01709 519040
www.craftsitedirectory.com/irisfolding

Quilling
www.cardinspirations.co.uk/demo/demo11.htm
www.creativepapercrafts.com/products/quilling.aspx

want to know more?

www.handcraftersvillage.com/quilling.htm
www.quilledcreations.com
www.quilling.com

Spirelli
www.art-of-craft.co.uk/acatalog/Spirelli.html
www.craftee.co.uk/spirellipacks.html
www.fidgetyfingers.co.uk/spirelli_card_making.htm
www.paperworkscardcraft.co.uk/acatalog/Spirelli.html

Teabag folding
http://mystudio3d.tripod.com/teabag.htm
http://pages.prodigy.net/rubyburns/cutouts.html
www.cardinspirations.co.uk/demo/teabag1.htm
www.scrapbookscrapbook.com/tea-bag-folding-instructions.html
www.teabagfolding.circleofcrafters.com

magazines

Card Making and Papercraft (*see* www.cardmakingandpapercraft.com)
Craft Creations (*see* www.craftcreations.co.uk)
Creative Card Making Ideas (*see* www.ccmimag.co.uk)
and go to www.themulberry-bush.com for a whole range of card making
magazines from which to choose.

books

The Art of Card Making (Apple Press, 2005)
The Big Book of Handmade Cards and Gift-wrap, Vivienne Bolton (New
 Holland, 2004)
120 Celebration Cross Stitch Cards, Gillian Souter (David & Charles, 2005)
Compendium of Card Making Techniques, Judy Balchin et al (Search Press,
 2005)
The Complete Guide to Card Making, Sarah Beaman (Collins & Brown, 2003)
Cross Stitch Greetings Cards, various (David & Charles, 2004)
*Paper Creations, Cards and Gifts: Over 30 Paperfolded Designs Featuring
 Origami, Iris and Teabag Folding*, Steve Biddle and Megumi Biddle (David
 & Charles, 2006)
Iris Folding Compendium (three books), Maruscha Gaasenbeek, Tine Beauveser
 (Forte Uitgevers, Netherlands – text is in English – 2003, 2004, 2006)
Quilling for Beginners, Jean Woolston Hamey (Kangaroo Press, 2004)
Quilling for Scrapbooks and Cards, Susan Lowman (Chapelle, 2005)
Tea Bag Folding: Designs and Techniques, Janet Wilson, Tiny van der Plas
 (Search Press, 2001)

Index

Index

Acknowledgments

We would like to thanks CJ Crafts for the use of their design on page 96. This is just one of many – to see more of their designs, contact them at 9 Shoreham Drive, Moorgate, Rotherham, South Yorkshire S60 3DT; tel: 01709 519040; cjcrafts@shebang.freeserve.co.uk.

⚙ Collins need to know?

Look out for these recent titles in Collins' practical and accessible
need to know? series.

Other titles in the series:

To order any of these
titles, please telephone
0870 787 1732 quoting
reference **263H**.
**For further information
about all Collins books,
visit our website:
www.collins.co.uk**